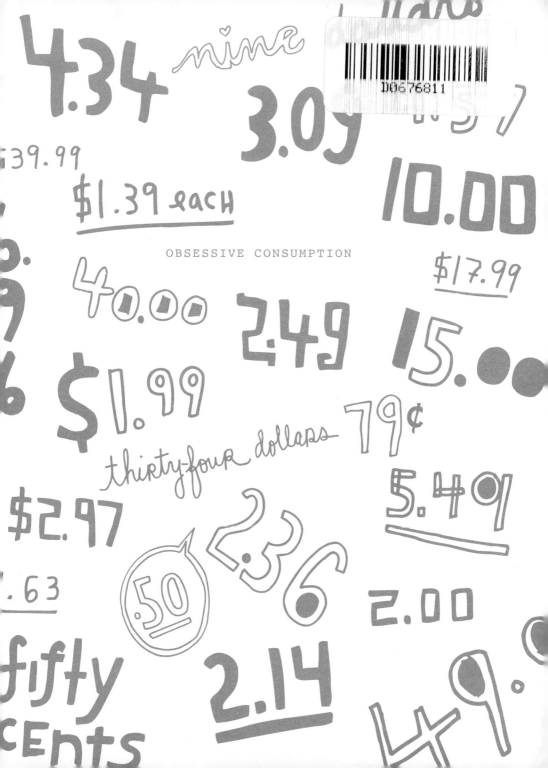

OBSESSIVE CONSUMPTION

# OBSESSIVE CONSUMPTION

*WHAT DID YOU BUY TODAY?*

Kate Bingaman-Burt

Princeton Architectural Press, New York

Published by
Princeton Architectural Press
37 East Seventh Street
New York, New York 10003

For a free catalog of books, call 1.800.722.6657.
Visit our website at www.papress.com.

Editor: Clare Jacobson
Designers: Deb Wood and Bree Anne Apperley

Special thanks to: Nettie Aljian, Sara Bader,
Nicola Bednarek, Janet Behning, Becca Casbon, Carina Cha,
Penny (Yuen Pik) Chu, Carolyn Deuschle, Russell Fernandez,
Pete Fitzpatrick, Wendy Fuller, Jan Haux, Erin Kim,
Aileen Kwun, Linda Lee, Laurie Manfra, John Myers,
Katharine Myers, Dan Simon, Andrew Stepanian,
Katie Stokien, Jennifer Thompson, Paul Wagner,
and Joseph Weston of Princeton Architectural Press
—Kevin C. Lippert, publisher

Library of Congress Cataloging-in-Publication Data
Bingaman-Burt, Kate, 1977–
Obsessive consumption : what did you buy today? /
Kate Bingaman-Burt.
     p. cm.
 ISBN 978-1-56898-890-0 (alk. paper)
1.  Bingaman-Burt, Kate, 1977– 2.  Commercial products in
art. 3.  Consumption (Economics) in art.  I. Title.
NC139.B498A4 2010
741.092—dc22
                                                2009018103

# CONTENTS

# INTRODUCTION

Parking tickets, coffee, packs of gum, shoes, electricity
bills, and burritos. I have been drawing something that
I purchase every day since February 5, 2006. *Obsessive
Consumption* represents a selection of these daily drawings.
I draw objects that are rather ordinary: Coke cans, Post-
it notes, toilet bowl cleaner—sundry items that a lot
of consumers have a shared experience with; items that
we interact with, but don't really think about. I love
documenting the mundane and, in turn, putting a personal
face on something that is mass-produced.

I make work about personal consumerism, market
economies, guilt, joy, excess, more guilt, gifts,
celebration, repetition, and the community of these shared
experiences. Why focus on consumerism? Money and purchasing
and the problems with money and the emotional connection to
buying products have been a constant in my life. When the
women in my family get together, we go shopping. We discuss
important issues in our lives over sale racks instead of
the kitchen table. This is how I learned to communicate.

My first venture into documenting what I call
Obsessive Consumption began in 2002, when I started
photographing everything I purchased. This project lasted
for two years. In the fall of 2004 I began to hand draw my

credit card statements. I'll continue drawing them until they are all paid off. The drawings in this book started as a guilty pleasure—a break from drawing those statements, which are not too enjoyable to draw (which is the point, of course). I don't draw everything I buy, but I select one item every day. Why just one? Some days I purchase several things, other days I have to divide my gas bill by thirty-one to figure out the total I am paying for heat that day. Some days I purchase a cheap object, like a fake mustache, simply because I want to draw it. My Obsessive Consumption appears in many other forms as well: installations at galleries, zines that I send to subscribers, blog posts that I update every other day, handmade pillows with appliquéd dollar signs, and debt dresses embroidered with charges from my credit cards.

The history of objects and the story of things have always fascinated me. Whenever I found an interesting item in a thrift store, I wanted to know its story. It frustrated me that I could never know the narrative of other people's castoffs, so I turned to myself and started documenting my own patterns and stories of consumption. Looking back at the drawings in this book, I recognize that I've documented a lot of Kate-specific (but still common)

items: wedding bands, a dog, a moving truck, items handmade by friends, Mississippi beer, Portland pizza, LOTS of pens to support my drawing habit, and drawing paper to lay down these images that I was consuming.

When I first started making work about consumption I altered my purchasing habits. I was worried that viewers would judge me for what I bought and so became a bit terrified to purchase anything. But soon, documenting my purchases became second nature to me. I don't censor, I just construct a narrative through my everyday objects. The drawings in this book were made during good economic times and bad, but my simple purchases of toothpaste and magazines stayed pretty much the same. Since I've been making work about consumerism for so long now, my art and my life have become rather seamless. At this point, I'm so far into it that I'm unable to make a clear observation of why I do what I do. I don't know when—or if—I'll stop making my daily drawings, but I expect I'll not stop my work on Obsessive Consumption.

People feel they know me because they've seen what's on my shopping list or what's in my bank account. But I just stage glimpses into my life. I work with universal imagery that almost anyone can identify with. I leave it

open to viewers to construct a narrative either about me or about their own experiences with the objects that I am working with. The interpretation is up to them.

Obsessive Consumption allows me to have a conversation with a range of people—from a thirteen-year-old girl who loves *Teen Vogue* to a middle-aged anti-consumer advocate. I never wanted to be an art observer. I'm instead an active participant in art, filtering my experiences with consuming into my work. Through my daily drawings I can be critical of myself—make fun of and even laugh at myself. Obsessive Consumption lets me document my experiences through this over-stimulating, sometimes joyous, sometimes nauseating world of consumer culture.

# FROM A TANK OF GAS TO NEW MARRIED CHECKS

**First National Bank Omaha**

**VISA**

Payment due date: FEB. 14, 200_
New Balance: $1,566 54
minimum payment due: $41.0_

Kate Bingaman
PO BOX 455
Mississippi State, MS 39762
||.||..||||...|..||||..||||...|..||||.|..||.||.|.||..|

First National Bank Omaha
PO BOX 2951
Omaha, NE 68103-2951

First National Bank
Omaha $ ☐☐☐☐☐☐ . ☐☐

PREMIER EDITION® VISA

## PAYMENT DUE
| | |
|---|---|
| Statement closing | 1.20.06 |
| Days in Billing Cycle | 30 |
| Payment due date | 2.14.06 |
| Amount Past Due $ | 0.00 |
| Min Payment Due $ | 41.00 |

## ACCOUNT SUMMARY
| | |
|---|---|
| Previous Balance | $ 1,590.49 |
| Payment & Credits | -$ 50.00 |
| New Transactions + $ total billed | 0.00 |
| Finance Charges + $ | 26.05 |
| New Balance | $ 1,566 54 |

## CREDIT LINE
| | |
|---|---|
| Total Credit Limit | $ 8,000 |
| Cash Limit | $ 4,000 |
| Available Credit | $ 0.00 |
| Available Cash | $ 0.00 |

| PURCHASE DATE | POST DATE | TRANSACTION SUMMARY | PAYMENTS & CREDITS | NEW TRANSACTIONS |
|---|---|---|---|---|
| 1.10 | 1.11 | ONLINE PAYMENT THANKYOU | $50 00 - | |

| CHARGE SUM. | AVERAGE DAILY BALANCE | DAILY PERIODIC | CORRESPONDING APR | Annualized APR |
|---|---|---|---|---|
| PURCHASES | $ 0.00 | $1,584.80 | 0.0548% | 19.990% | 20.00% |
| CASH | $ 0.00 | $ 0.00 | 0.0602% | 21.990% | 0.00% |

BILLED PERIODIC RATE   FINANCE CHARGE $ 26.05

**NEED HELP?** ONLINE ACCESS
www.firstnational.com
CUSTOMER SERVICE

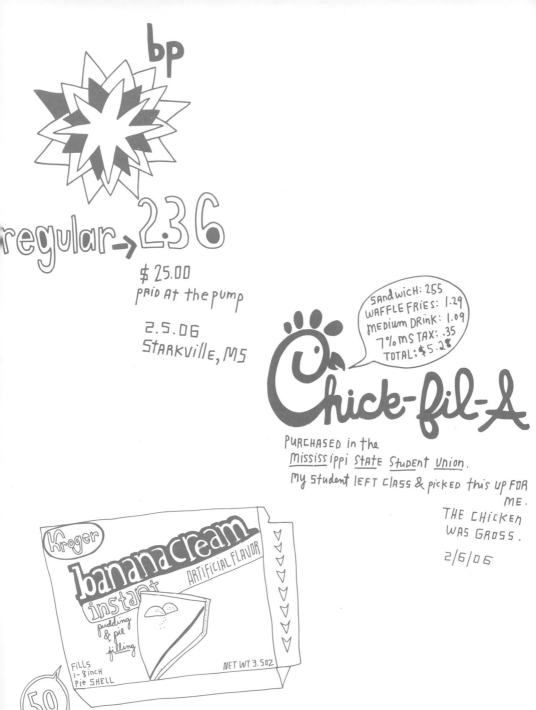

bp

regular → 2.36

$ 25.00
paid at the pump

2.5.06
Starkville, MS

Sandwich: 2.55
Waffle Fries: 1.29
Medium Drink: 1.09
7% MS Tax: .35
Total: $5.28

Chick-fil-A

Purchased in the
Mississippi State Student Union.
My student left class & picked this up for
ME.
THE CHICKEN
WAS GROSS.

2/6/06

Kroger
banana cream
ARTIFICIAL FLAVOR
instant
pudding
& pie
filling

FILLS
1 - 8 inch
Pie Shell

NET WT 3.5 OZ

.50

2.07.06

6 CL iP

BO AR DS...
$1.39 each

2.08.06

HOLLYWOOD PREMIER

CINEMAS

HOLLYWOOD PREMIER CINEMAS
BROKEBACK [8]
RATED: R
Thur. FEB 9  7:00 PM
ADULT $7.00  #8
Price includes $0.46tax  2/9/2006 6:50:55PM
Phone: (662) 320-9000

2.9.06

Pizza Hut

Gather 'round the GOOD Stuff

15.00  ONE LARGE
CHEESE PIZZA
PAN CRUST

I ate Half. He ate Half.

2.10.06

4 color click pen

$1.99

I BOUGHT this to PAY Bills.

2.11.06

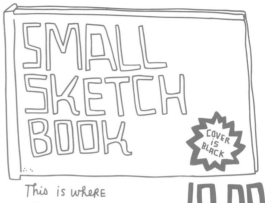

SMALL SKETCH BOOK

COVER IS BLACK

This is wHeRe I KEEP my DRAWINGS.

10.00

2.12.06

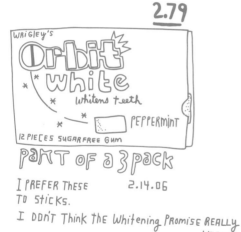

2.79

WRIGLEY'S

Orbit white

whitens teeth

PEPPERMINT

12 PIECES SUGARFREE Gum

PaRT OF a 3 pack

I PREFER THESE TO Sticks.

2.14.06

I DON'T Think the Whitening PROMISE REALLY WORKS.

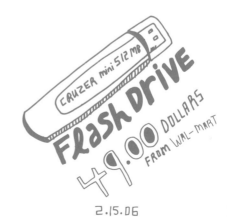

CRUZER mini 512 MB

Flash DRIVE

49.00 DOLLARS

FROM WAL-MART

2.15.06

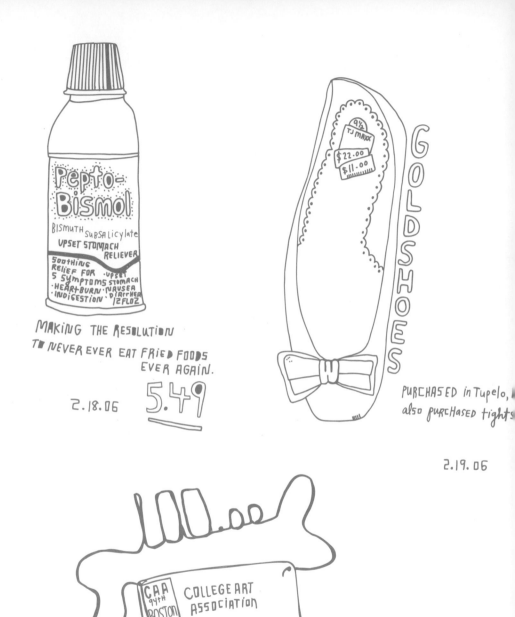

Pepto-Bismol

BISMUTH SUBSALICYLATE
UPSET STOMACH
RELIEVER

Soothing
Relief for ·UPSET
5 SYMPTOMS STOMACH
·HEARTBURN ·NAUSEA
·INDIGESTION ·DIARRHEA
·12 FLOZ

MAKING THE RESOLUTION
TO NEVER EVER EAT FRIED FOODS
EVER AGAIN.

2.18.06     5.49

GOLD SHOES

9½
TJ MAXX
$22.00
$11.00

PURCHASED in Tupelo,
also purchased tights

2.19.06

100.00

CAA
94th
BOSTON
FEB 22-25
2006

COLLEGE ART
ASSOCIATION

KATE BINGAMAN
Mississippi State University

2.23.06

12

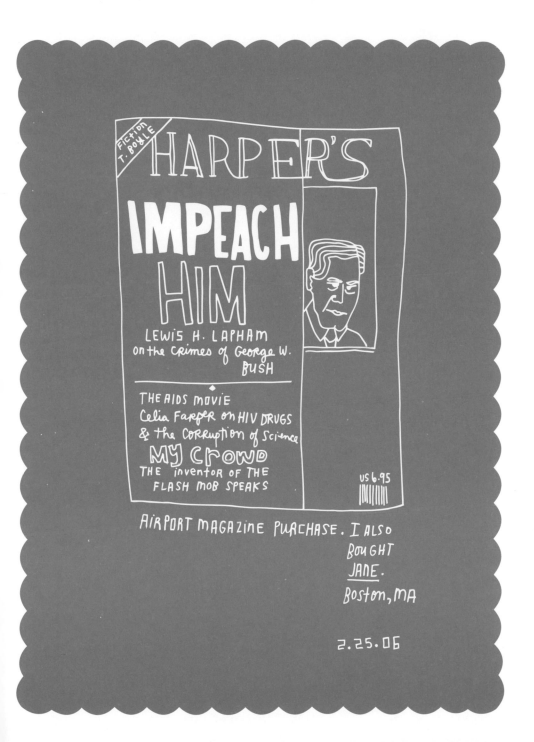

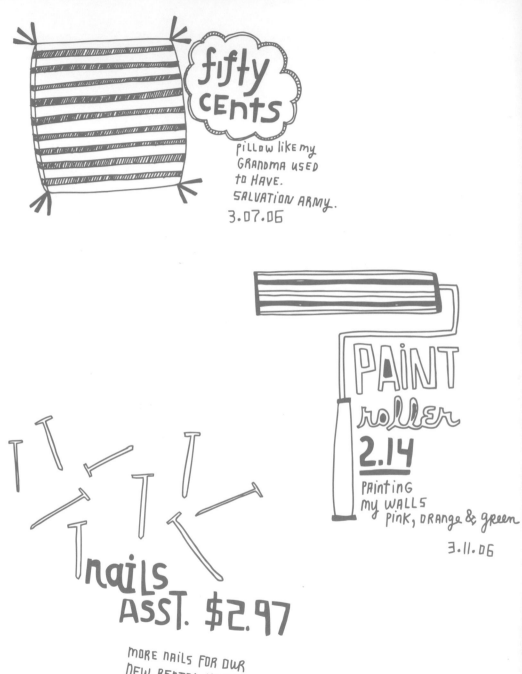

*fifty cents*

pillow like my GRANDMA USED to HAVE. SALVATION ARMY. 3.07.06

PAINT roller 2.14

PAINtiNG MY WALLS PiNK, ORANGe & green

3.11.06

nails ASST. $2.97

MORE NAiLS FOR OUR NEW RENTAL HOUSE.

3.15.06

14

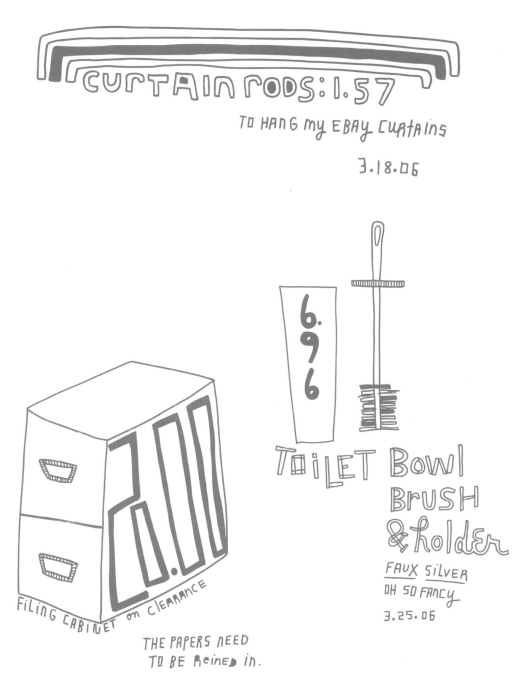

CURTAIN RODS: 1.57

TO HANG MY EBAY CURTAINS

3.18.06

6.96

TOiLET Bowl BRUSH & holDER

FAUX SILVER
OH SO FANCY
3.25.06

20.00

FiLiNG CABiNET on CLEARANCE

THE PAPERS NEED
TO BE ReiNeD iN.

3.26.06

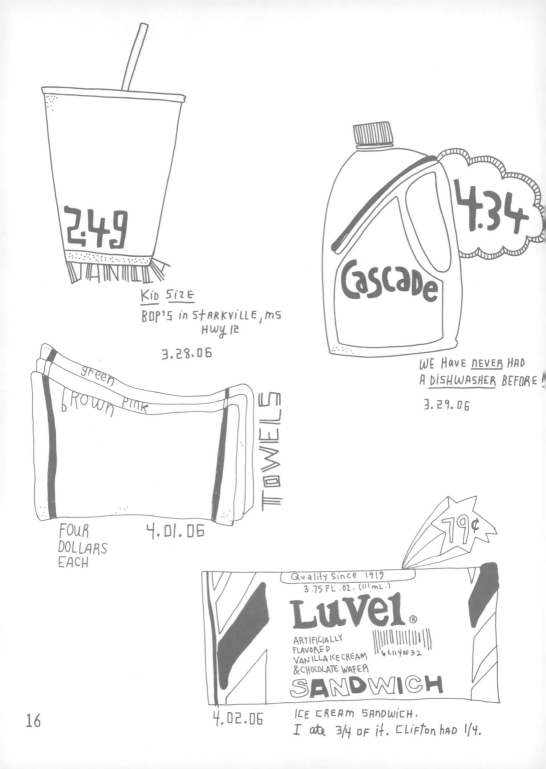

**2.49**

<u>KID SIZE</u>
BOP'S in STARKVILLE, MS
HWY 12

3.28.06

green
**BROWN** PINK

TOWELS

FOUR
DOLLARS
EACH

4.01.06

**Cascade** **4.34**

WE HAVE <u>NEVER HAD</u>
A <u>DISHWASHER</u> BEFORE!

3.29.06

**79¢**

Quality Since 1919
3.75 FL. OZ. (111 mL.)

**Luvel** ®

ARTIFICIALLY
FLAVORED
VANILLA ICE CREAM
& CHOCOLATE WAFER

**SANDWICH**

4.02.06    ICE CREAM SANDWICH.
I ate 3/4 of it. CLIFTON had 1/4.

16

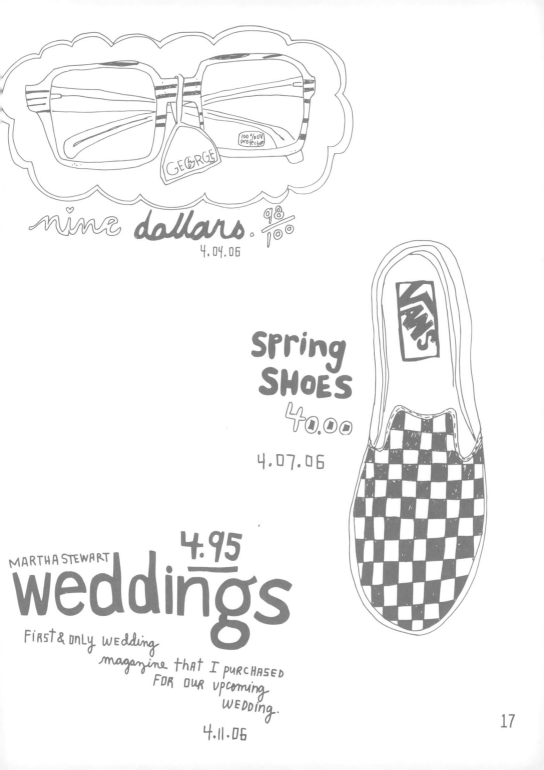

100 % UV Protection

GEORGE

nine dollars. $\frac{98}{100}$

4.04.06

spring
SHOES
40.00

4.07.06

VANS

MARTHA STEWART

4.95

weddings

FIRST & ONLY WEDDING magazine that I PURCHASED FOR OUR upcoming WEDDING.

4.11.06

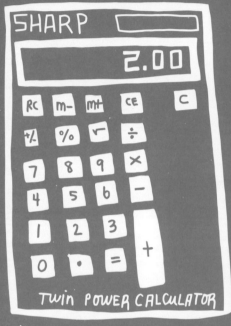

I LOSE SO many CALCULATORS.
I DON'T Know where THEY GO.
I THINK SOMEONE IS STEALING
THEM.

$ 3.50

4.12.06

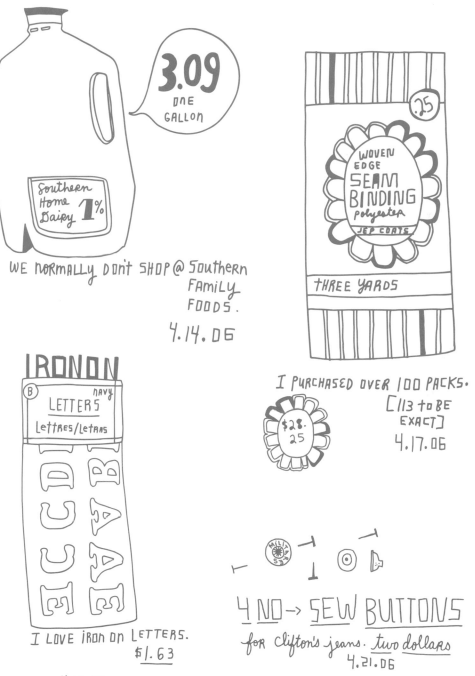

19

# Long Reach Stapler

FLIP CAP TO LOAD

## thirty-four dollars

EXCELLENT
PURCHASE.
NOW I CAN STAPLE ZINES ALL DAY LONG.

4.22.06

**Dirt Devil**

OUR CARPETS
ARE SO DIRTY.

This VACuum
is VERY SMALL

$39.99

4.23.06

$17.99

4.26.06

I STEPPED ON MY
OLD HEADPHONES.
THE NEW ONES
ARE JUST OK.

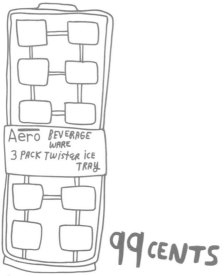

Aero BEVERAGE WARE
3 PACK Twister ice TRAY

**99 CENTS**

FOR SOME REASON I HAD THE HARDEST TIME FINDING ICE CUBE TRAYS.

4.28.06

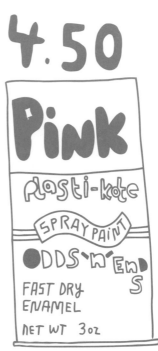

**4.50**

Pink
Plasti-kote
SPRAY PAINT
ODDS·N·ENDS
FAST DRY ENAMEL
NET WT 3oz

SPRAY PAINT FOR OUR WEDDING INVITES.
4.30.06

**8.00**

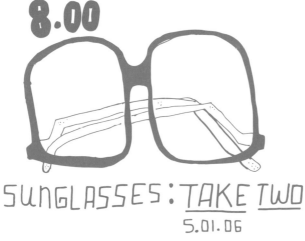

SUNGLASSES: TAKE TWO
5.01.06

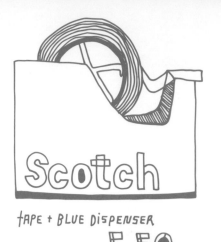

tape + BLUE DISPENSER

**5.50**

I LOSE TAPE.
A LOT.
5.02.06

Button FOR CLIFTON.
PURCHASED AT BACKROAD ANTIQUES
in STARKville

.50

5.03.06

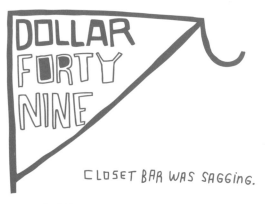

CLOSET BAR WAS SAGGING.

# LiME

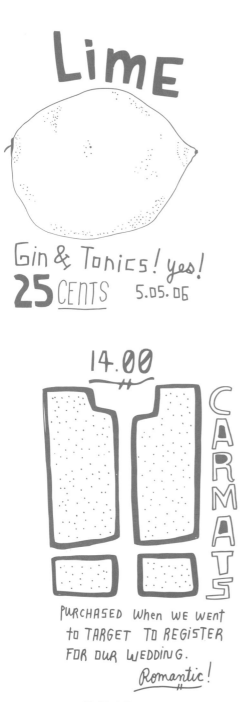

Gin & Tonics! yes!
**25** CENTS    5.05.06

14.00

CARMATS

PURCHASED When WE WENT
to TARGET TO REGISTER
FOR OUR WEDDING.
_Romantic!_

5.14.06

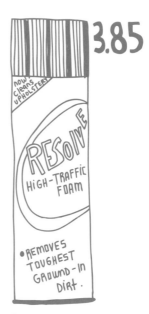

3.85

now
cleans
upholstery

RESOLVE
HiGH-TRAFFiC
FOAM

• REMOVES
TOUGHEST
GROUND-IN
DiRT.

Knocked over a liter
of Diet coke on the rug.

Some of these rug
stains are not ours.

5.07.06

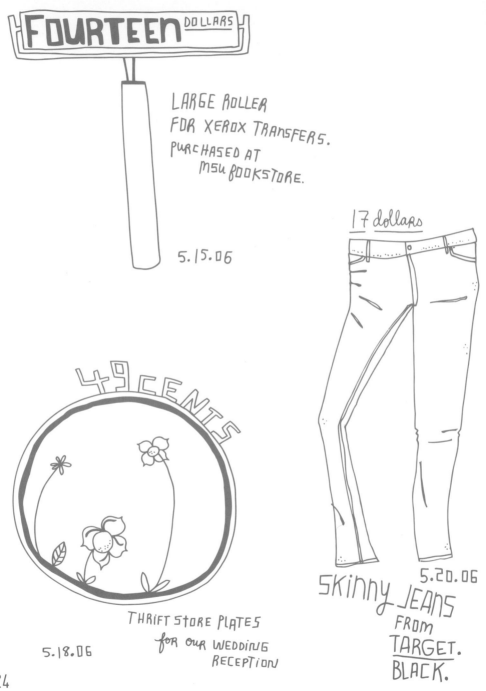

# FOURTEEN DOLLARS

LARGE ROLLER
FOR XEROX TRANSFERS.
PURCHASED AT
MSU BOOKSTORE.

5.15.06

17 dollars

SKINNY JEANS
FROM
TARGET.
BLACK.

5.20.06

49 CENTS

THRIFT STORE PLATES
for our WEDDING
RECEPTION

5.18.06

24

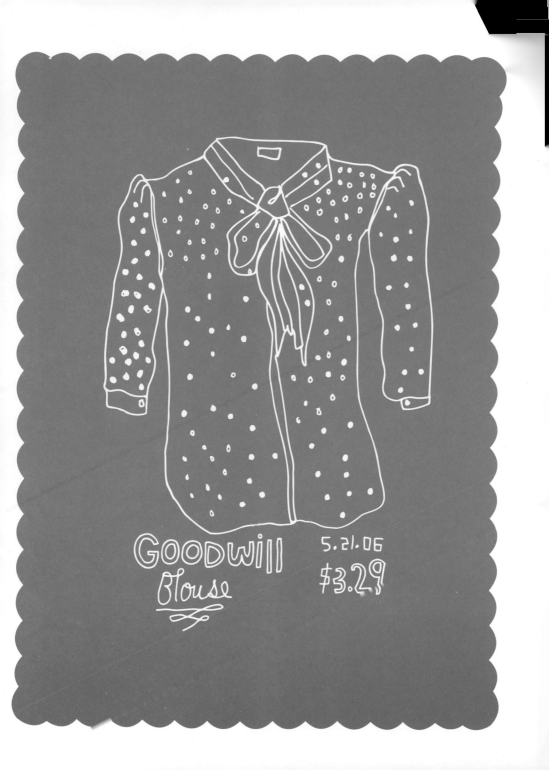

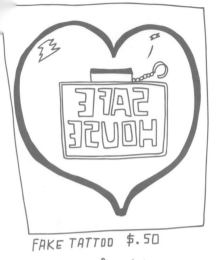

FAKE TATTOO  $.50

Uncle Paul took my sister & me
to THE SAFEHOUSE BAR in
Milwaukee, Wi.
LOVED it.

5.24.06

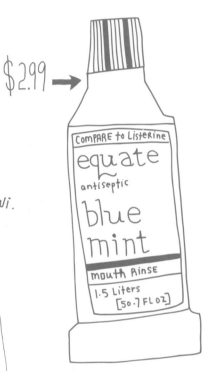

$2.99 →

COMPARE to Listerine
equate
antiseptic
blue
mint
mouth Rinse
1.5 Liters
[50.7 FL OZ]

WE NOW HAVE TWO BOTTLES
OF mouthwash. I thought
WE WERE OUT

5.27.06

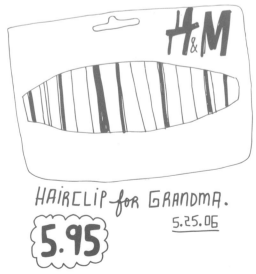

H&M

HAIRCLIP for GRANDMA.
5.25.06

5.95

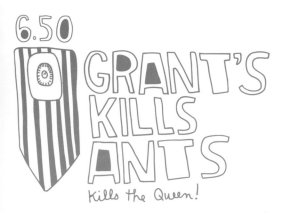

# 6.50

# GRANT'S KILLS ANTS

*Kills the Queen!*

DANG MISSISSIPPI ANTS. THIS TOTALLY KILLED THEM.

5.28.06

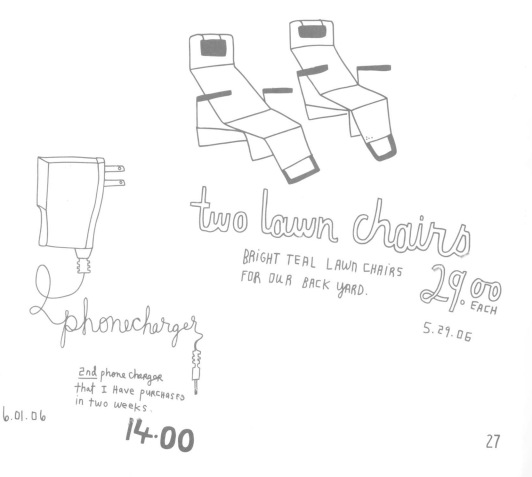

## two lawn chairs

BRIGHT TEAL LAWN CHAIRS
FOR OUR BACK YARD.

29.<u>00</u> EACH

5.29.06

*phonecharger*

<u>2nd</u> phone charger
that I HAVE PURCHASES
in two weeks.

6.01.06

14.00

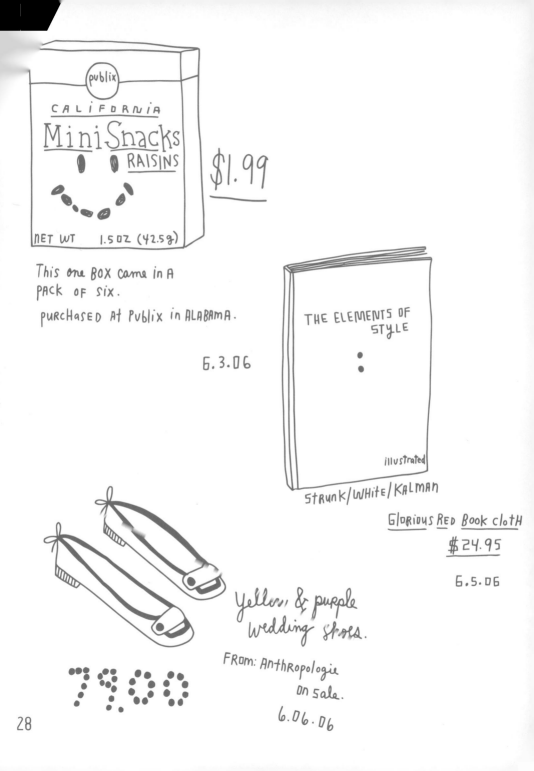

publix

CALIFORNIA
MiniSnacks
RAISINS

$1.99

NET WT 1.5 OZ (42.5g)

This one BOX came in A
PACK of SIX.

PuRCHaSED At Publix in ALABaMa.

6.3.06

THE ELEMENTS OF
STYLE

illustrated

STRUNK/WHitE/KALMAN

GlORiOUS RED Book clotH
$24.95

6.5.06

Yellow & purple
wedding shoes.

FROM: Anthropologie
On sale.

6.06.06

7.00

28

NETFLIX
SUBSCRIPTION: 16 BUCKS A MONTH.

NETFLIX ||||||||| 128666
Pirates of Silicon Valley
BASED ON A BOOK BY PAUL FREIBERGER,
THIS engrossing Dramatization tells
the tangled HISTORY of Apple Computer
& tech Giant MICROSOFT. Follow the
entwined Destinies of Apple's Hip Founder
Steve Jobs (NOAH Wyle) & MICROSOFT'S
Geeky Genius (Anthony Michael Hall)
AS they make History.

RATED NR    1 HR. 37 min
                    1999

THIS Just CAme in the mAil todAy.

6.07.06

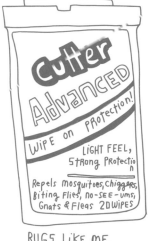

BUGS LIKE ME.
I DON'T LIKE THEM.

$ 4.69          6.08.06

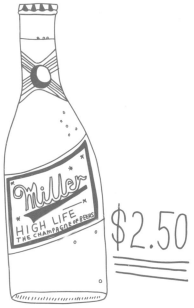

$2.50

I USED TO DRAW these ALL of
THE time. NOW, NOT SO much.
FAVORITE CHEAP BEER
                    6.09.06

29

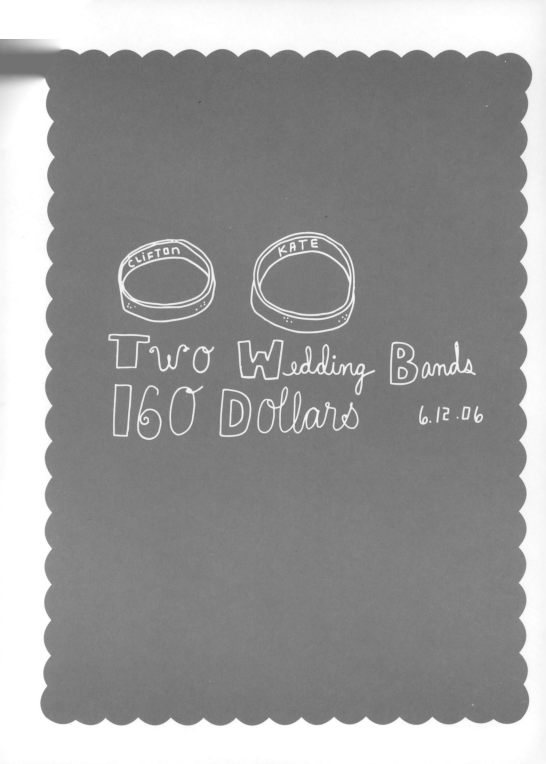

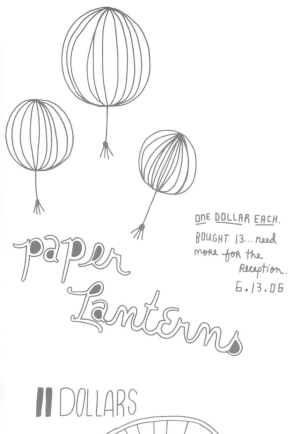

*paper Lanterns*

ONE DOLLAR EACH.
BOUGHT 13... need
more for the
Reception.
6.13.06

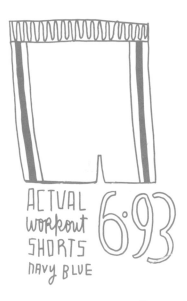

ACTUAL
workout
SHORTS
navy BLUE

6·93

6.14.06

II DOLLARS

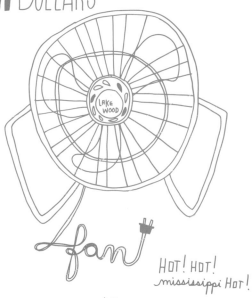

*fan*

HOT! HOT!
mississippi HOT!

6.16.06

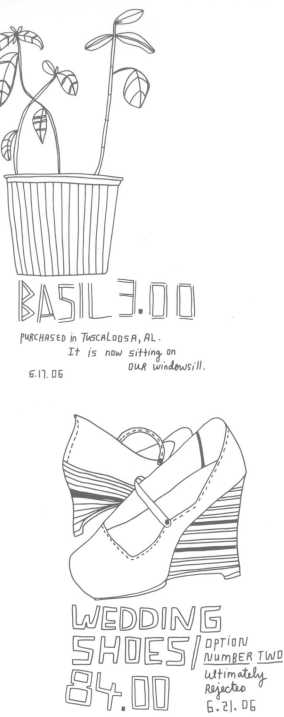

# BASIL 3.00

PURCHASED in TUSCALOOSA, AL.
It is now sitting on
OUR windowsill.
6.17.06

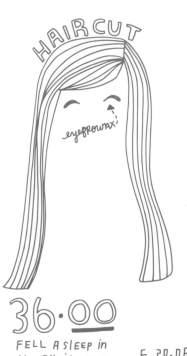

HAIRCUT

eyebrowax

# 36.00

FELL ASLEEP in
the CHAIR. I Always 6.20.06
DO THIS.

# WEDDING SHOES/ OPTION NUMBER TWO

# 84.00
ultimately
Rejected
6.21.06

32

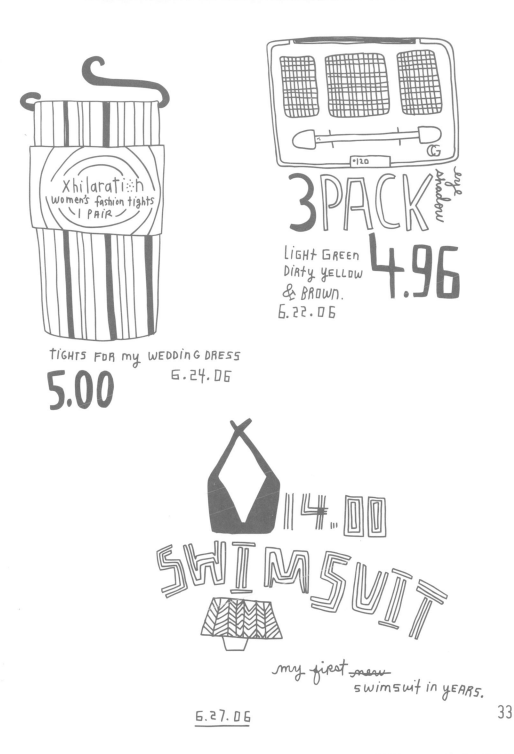

Xhilaration
women's fashion tights
— 1 PAIR —

3 PACK *eye shadow*

LIGHT GREEN
DIRTY YELLOW
& BROWN.
6.22.06

4.96

TIGHTS FOR MY WEDDING DRESS
6.24.06

5.00

14.00
SWIMSUIT

my first ~~new~~
swimsuit in YEARS.

6.27.06

33

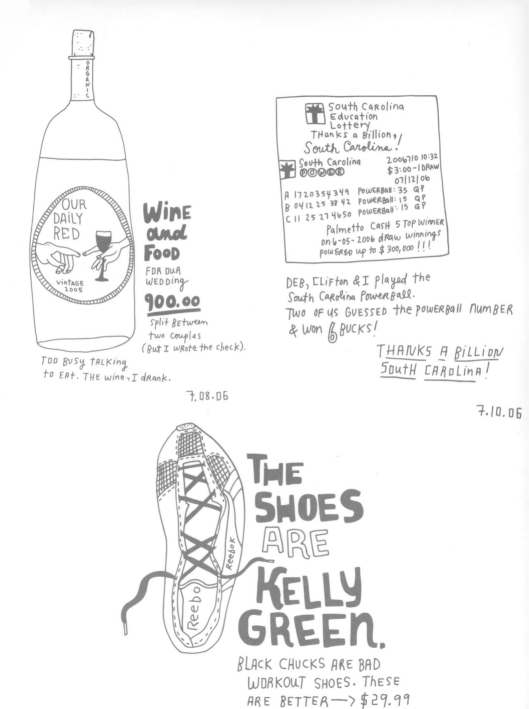

**Wine and Food**

FOR OUR WEDDING

**900.00**

Split Between two couples (But I wrote the check).

TOO BUSY TALKING to EAT. THE wine, I drank.

7.08.06

---

OUR DAILY RED

vintage 2005

ORGANIC

---

South Carolina Education Lottery
THanks a Billion,
*South Carolina!*

South Carolina **POWER** 2006710 10:32
$3:00 - 1 DRAW
07/12/06

A 1720354349  POWERBALL: 35  QP
B 0412 25 38 42  POWERBALL: 15  QP
C 11 25 27 4650  POWERBALL: 15  QP

Palmetto Cash 5 TOP WINNER
on 6-05-2006 draw winnings
POWERED up to $300,000 !!!

DEB, Clifton & I played the South Carolina Powerball. TWO OF US GUESSED the POWERBALL number & won 6 BUCKS!

THANKS A BILLION SOUTH CAROLINA!

7.10.06

---

**THE SHOES ARE KELLY GREEN.**

Reebok  Reebo  Reebok

BLACK CHUCKS ARE BAD WORKOUT SHOES. THESE ARE BETTER —> $29.99

34

7.19.06

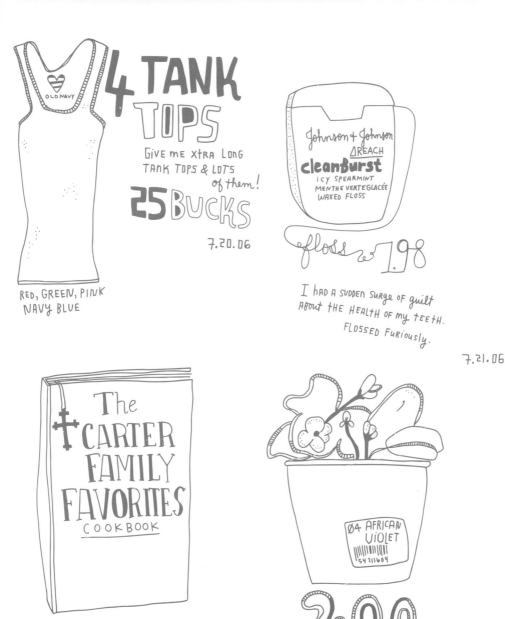

**4 TANK TOPS**

OLD NAVY

GIVE ME XTRA LONG
TANK TOPS & LOTS
of them!

**25 BUCKS**

7.20.06

RED, GREEN, PINK
NAVY BLUE

Johnson & Johnson
△REACH
**cleanBurst**
ICY SPEARMINT
MENTHE VERTEGLACÉE
WAXED FLOSS

floss ~ 1.98

I HAD A SUDDEN surge OF guilt
ABOUT THE HEALTH OF MY TEETH.
FLOSSED Furiously.

7.21.06

The
✝ CARTER
FAMILY
FAVORITES
COOKBOOK

04 AFRICAN
VIOLET
54 211604

**2:00**

7.26.06

BIRTHDAY PRESENT FOR CLIFTON.
PURCHASED ON EBAY. I thought this
was ABOUT THE <u>MUSIC</u> CARTER FAMILY,
But it was ABOUT THE <u>Jimmy</u> CARTER FAMILY.

**14.00**          7.25.06

35

JENS LEKMAN
OH YOU'RE SO SILENT

PURCHASED FROM iTunes : $9.99 each

7.28.06

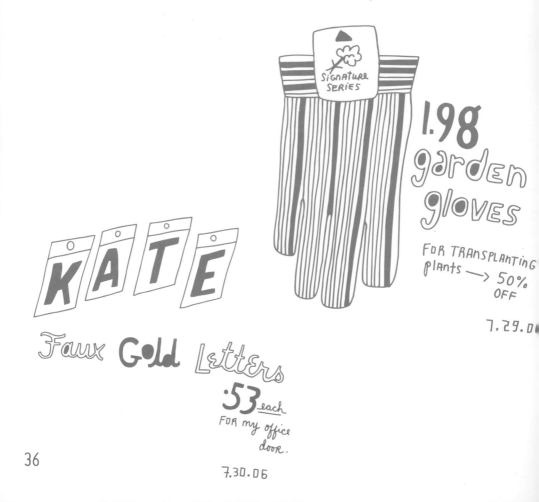

SIGNATURE SERIES

1.98 garden gloves

FOR TRANSPLANTING
plants → 50% OFF

7.29.0

KATE

Faux Gold Letters
.53 each
FOR my office door.

36

7.30.06

CLIFTON BURT
KATE BINGAMAN-BURT
PO BOX 455 MS STATE, MS

1004

Date _____

PAY TO THE
ORDER OF _____  $ [          ]

_____ DOLLARS

CA DE NCE

MEMO _____

NEW MARRIED
CHECKS.
13.00

8.01.06

# FROM A
# SHELTER
# DOG
## TO A
# BLACK
# CARDIGAN

APPLE CREDIT ACCOUNT

# MBNA
At Your Service
www.mbnanetaccess.com
CUSTOMER SINCE 2002

MAKE CHECKS PAYABLE
to MBNA AMERICA
PO BOX 15289
Wilmington, DE 19886-5289

| PAYMENT DUE | NEW BALANCE |
|---|---|
| 08/19/06 | $1,793.76 |
| Total min Payment | Amount ENCLOSED |
| $47.00 | |

DETACH TOP PORTION

KATE BINGAMAN
PO BOX 455
MS STATE UNIV MS 39762

| CREDIT LINE | CASH OR CREDIT | | CLOSE DATE | TOTAL DUE | PAYMENT DUE DAY |
|---|---|---|---|---|---|
| $2,400.00 | $606.24 | 32 | 07/22/06 | $47.00 | 08/19/06 |

| POST IN DATE | TRANS DATE | REF num. | CATEGORY | Transactions AUGUST 2006 STATEMENT | CHARGES | CREDITS |
|---|---|---|---|---|---|---|

PAYMENTS & CREDITS

07/18    PAYMENT - NET ACCESS                                      75.00 CR

$0.00    $75.00 CR

IMPORTANT
NEWS

PAY YOUR BILL QUICKLY WITH PAY-BY-PHONE SERVICE.
CALL 1·866·628·8957 TO USE THIS AUTOMATED SERVICE.
PAYMENT POSTS THE SAME OR NEXT BUSINESS DAY.

## SUMMARY OF TRANSACTIONS

| PREVIOUS BALANCE | (-) PAYMENTS & CREDITS | (+) Advances | (+) PERIODIC Rate Finance | (+) NEW BALANCE | TOTAL min PAYMENT DUE |
|---|---|---|---|---|---|
| $1,838.91 | $75.00 | $0.00 | $29.85 | $1,793.76 | Past Due.. .. $0.00 |
| | | | | | CURRENT.... $47.00 |
| | | | | | TOTAL min PAYMENT..... $47.00 |

| FINANCE CHARGE SCHEDULE Category | PERIODIC RATE | APR | BALANCE SUBJECT TO CHANGE |
|---|---|---|---|
| A. ADVANCES | 0.050657% DLY | 18.49 | 1,739.76 |
| B. ADVANCES | 0.050657% DLY | 18.49 | |
| C. OTHER CHARGES | 0.050657% DLY | 18.49 | $0.00 |
| | | | $101.93 |

FOR THIS BILLING PERIOD
A P R ——→18.49%

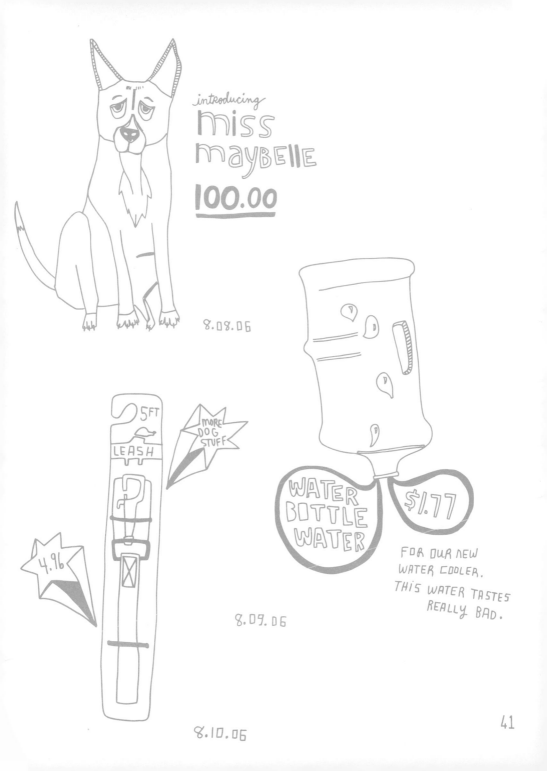

*introducing*

## miss maybelle

## 100.00

8.08.06

5FT

LEASH

MORE DOG STUFF

4.96

8.09.06

WATER BOTTLE WATER

$1.77

FOR OUR NEW WATER COOLER. THIS WATER TASTES REALLY BAD.

8.10.06

41

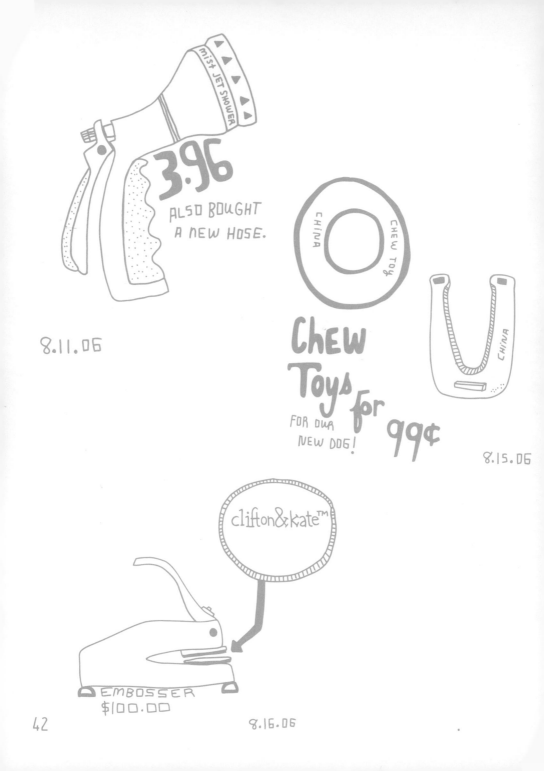

mist JET SHOWER

3.96

ALSO BOUGHT
A NEW HOSE.

8.11.06

CHINA
CHEW TOY

CHINA

CHEW
Toys for 99¢
FOR OUR
NEW DOG!

8.15.06

clifton&kate™

EMBOSSER
$100.00

42

8.16.06

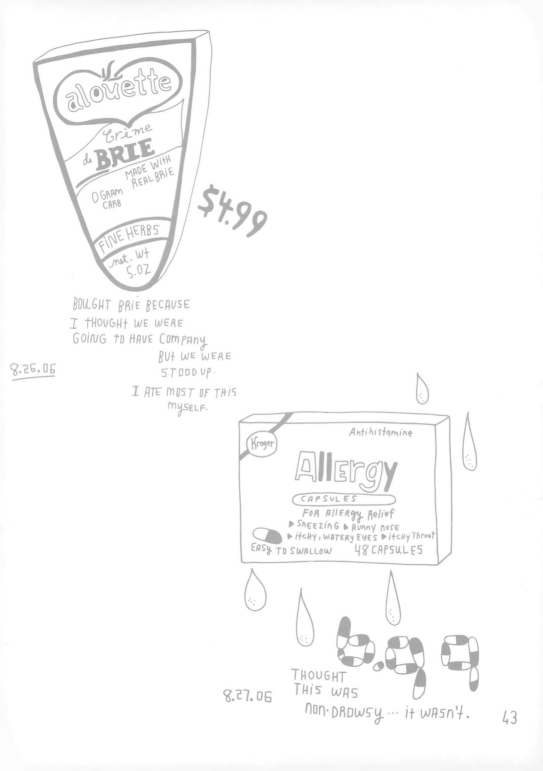

alouette

Crème de **BRIE**

MADE WITH REAL BRIE

0 GRAM CARB

FINE HERBS

net. wt 5.0Z

$4.99

BOUGHT BRIE BECAUSE I THOUGHT WE WERE GOING TO HAVE COMPANY BUT WE WERE STOOD UP. I ATE MOST OF THIS MYSELF.

8.26.06

Kroger

Antihistamine

**Allergy**

CAPSULES

FOR ALLERGY Relief
▶ SNEEZING ▶ RUNNY NOSE
▶ itchy, WATERY EYES ▶ itchy Throat

EASY TO SWALLOW    48 CAPSULES

8.27.06

THOUGHT THIS WAS NON·DROWSY ... it WASN'T.

43

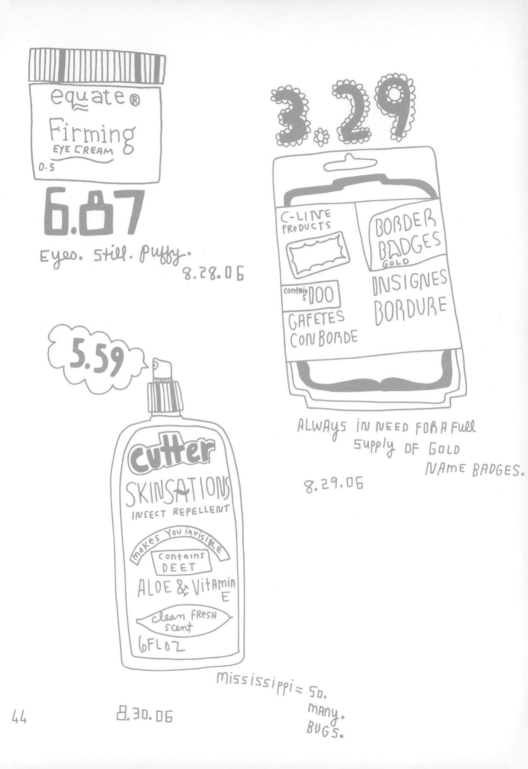

equate®
Firming
EYE CREAM
0.5

6.87

Eyes. Still. Puffy.
8.28.06

3.29

C-LINE
PRODUCTS

BORDER
BADGES
GOLD

Contains
$100

INSIGNES
BORDURE

GAFETES
CON BORDE

ALWAYS IN NEED FOR A FULL
SUPPLY OF GOLD
NAME BADGES.

8.29.06

5.59

Cutter
SKINSATIONS
INSECT REPELLENT
makes you invisible
Contains
DEET
ALOE & Vitamin
E
clean FRESH
scent
6 FL OZ

Mississippi = 50.
MANY.
BUGS.

8.30.06

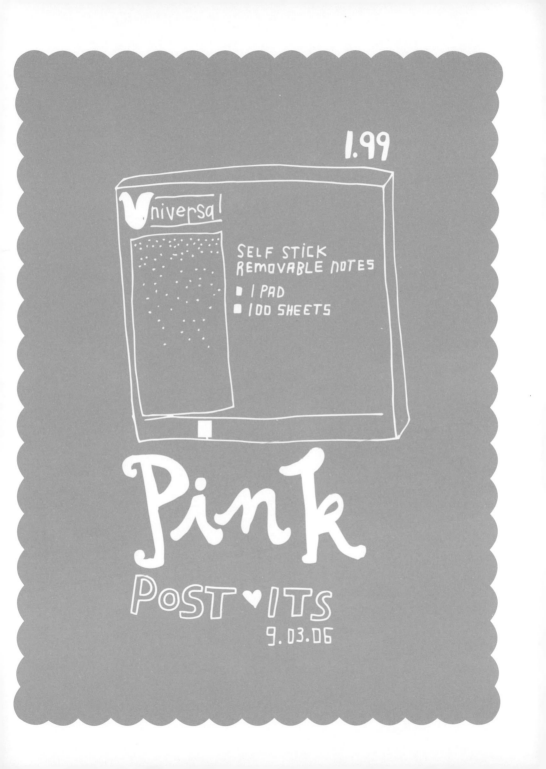

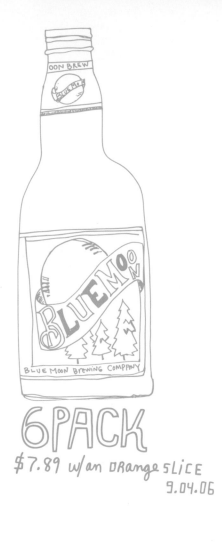

6PACK

$7.89 w/an ORange sLiCE
9.04.06

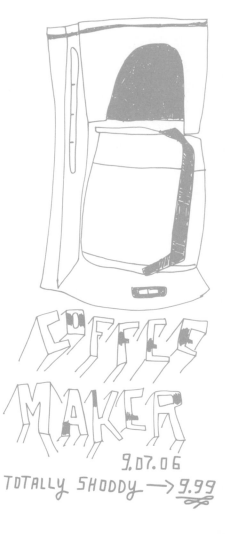

COFFEE
MAKER

9.07.06
TOTALLY SHODDY —> 9.99

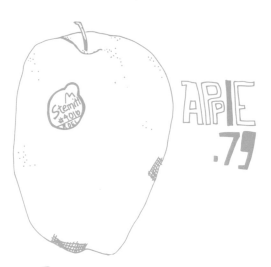

APPLE
.79

9.12.06
FUJIS WERE OUT OF
stock.

PLASTIC ¢ 99 CENTS
fANGS

JUST FOR WEARING
AROUND the HOUSE.
9.13.06

Dove

9.15.06

1/4 fresh
hydrating
lotion
BAR
SOAP
1.39

47

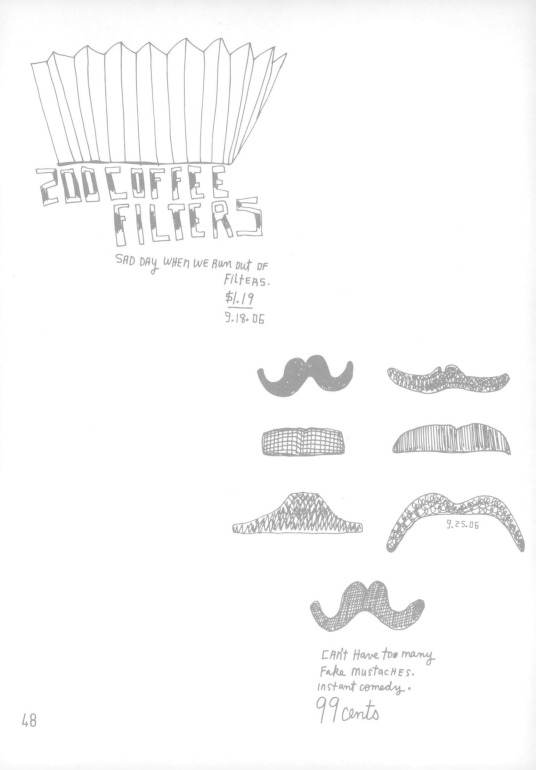

200 COFFEE FILTERS

SAD DAY WHEN WE RUN OUT OF FILTERS.
$1.19
9.18.06

9.25.06

CAN'T HAVE TOO MANY FAKE MUSTACHES. INSTANT COMEDY.

99 cents

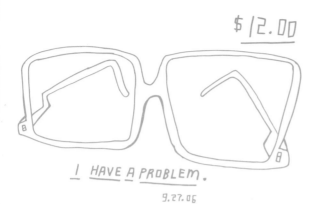

$ 12.00

I HAVE A PROBLEM.

9.27.06

9.30.06

HE-MAN & G.I. JOE
MASK      MASK

10 CENTS EACH.

49

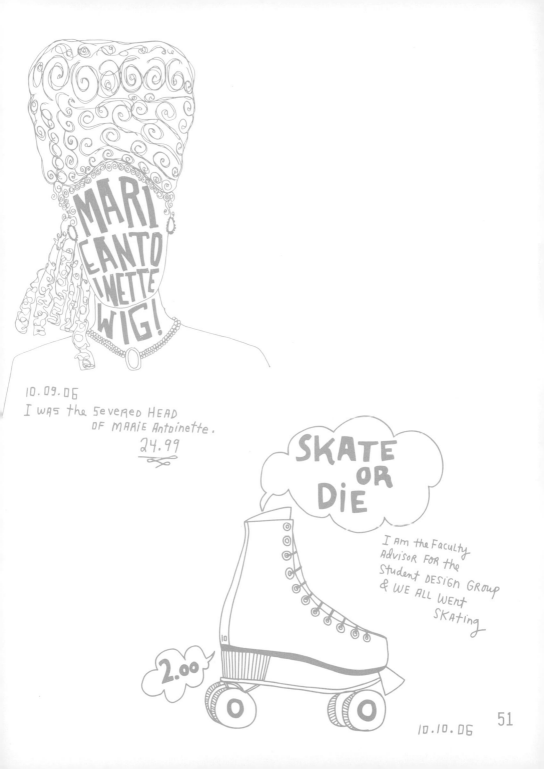

10.09.06
I WAS the SEVERED HEAD
    OF MARIE Antoinette.
            24.99

I Am the Faculty
Advisor FOR the
Student DESIGN GROUP
& WE ALL Went
        SKAting

10.10.06    51

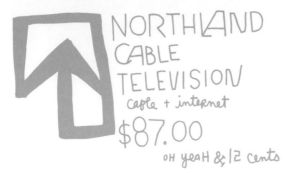

NORTHLAND
CABLE
TELEVISION
cable + internet
$87.00
OH YEAH & 12 cents

10.11.06

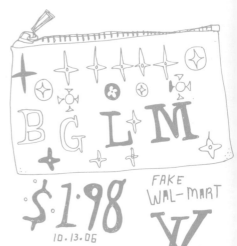

B G L M

$1.98    FAKE
WAL-MART

LV

10.13.06

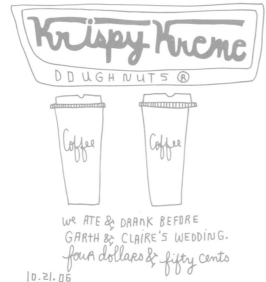

WE ATE & DRANK BEFORE
GARTH & CLAIRE'S WEDDING.
four dollars & fifty cents

52

10.21.06

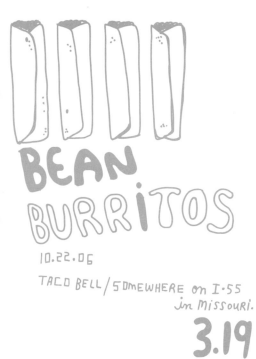

BEAN
BURRITOS

10.22.06

TACO BELL / SOMEWHERE ON I·55
in MISSOURI.

**3.19**

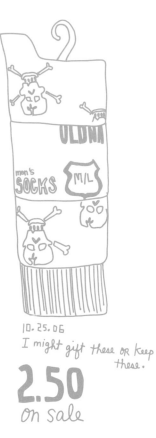

ULDNA

men's
SOCKS    M/L

10.25.06

I might gift these or keep
these.

**2.50**
on sale

10.28.06

TWENTY — FOUR DOLLARS 95¢
FOR my SISTER.

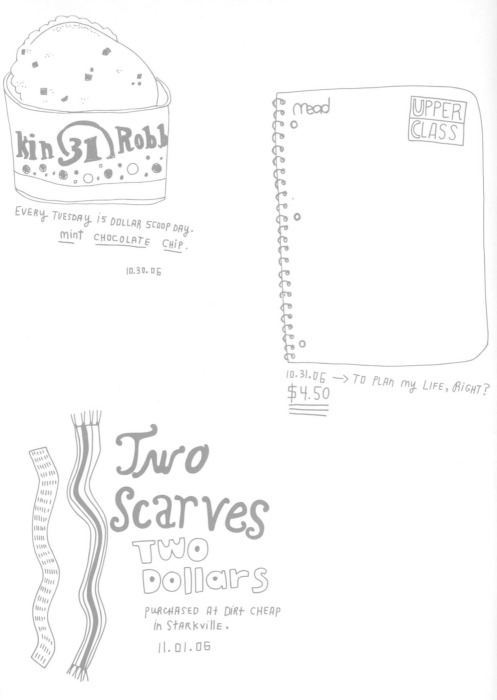

kin 31 Robl

EVERY TUESDAY IS DOLLAR SCOOP DAY.
<u>mint</u> CHOCOLATE CHIP.

10.30.06

mead

UPPER
CLASS

10.31.06 → TO PLAN MY LIFE, RIGHT?
$4.50

Two Scarves TWO Dollars

PURCHASED AT DIRT CHEAP
in Starkville.

11.01.06

# COTTON
## District LANDLORD

APT. RENT ⟶ 650.00

11. 06. 06

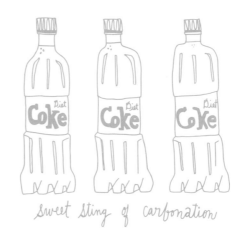

sweet sting of carbonation

11. 07. 06

COKES FOR
CLifton, Will & ME!
FROM THE ARCHITECTURE
BUILDING COKE MACHINE.
$ 3.00

PERFECTION
Textured
Cotton
Rounds

— Soft, Gentle &
— Strong —

COtton
80
Textured Cotton Rounds

11. 10. 06  to Remove makeup
PURCHASED @ Walgreen's / $1.99

55

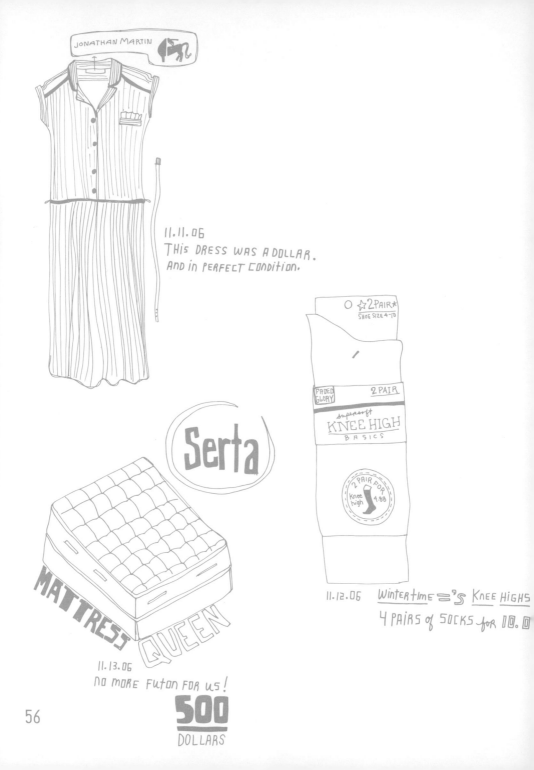

JONATHAN MARTIN

11.11.06
THIS DRESS WAS A DOLLAR.
AND IN PERFECT CONDITION.

☆ 2 PAIR ★
SHOE SIZE 4-10

FADED GLORY    2 PAIR

supersoft
KNEE HIGH
BASICS

2 PAIR FOR
Knee high  4.88

Serta

MATTRESS QUEEN

11.13.06
NO MORE FUTON FOR US!

500
DOLLARS

11.12.06    WINTERTIME ='S KNEE HIGHS
4 PAIRS OF SOCKS FOR 10.0

50 cents
EACH

13   FRAMES   Palmer thrift Home

11.14.06
NUMBER ONE THRIFT STORE
WORKER DENNIS GAVE ME
A SUPER DEAL.

9.99

HELLO BACKPAIN!
I Am sitting in the most
UNCOMFORTABLE COMPUTER DESK
CHAIR in NORTHERN
mississippi.

11.16.06

mac & cheese

# Kentucky Fried Chicken

BISCUIT

COLE
SLAW

MASHED
POTATOES

ONE OF my FAVORITE FAST
FOOD MEALS:
KFC SIDES!

11.20.06                    $4.89

DOG
NAIL
CLIPPING

I HATE CLIPPING
OUR DOG'S NAILS.

7.00

FROM THE FARMERS' CO·OP!

11.21.06

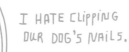

FACTS ABOUT NORWAY
8TH EDITION
Aftenposten

11.22.06
Lovely . Little . Book .
25 ¢

BUY NOTHING DAY

though I am pretty
sure I bought a
Diet Coke.
11.24.06    75¢

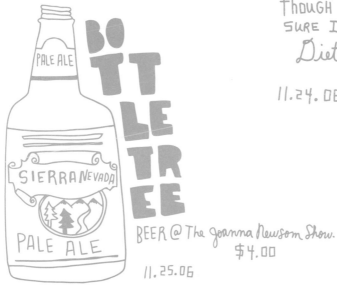

PALE ALE
SIERRA NEVADA
PALE ALE

BOTTLE TREE

BEER @ The Joanna Newsom Show.
$4.00

11.25.06

59

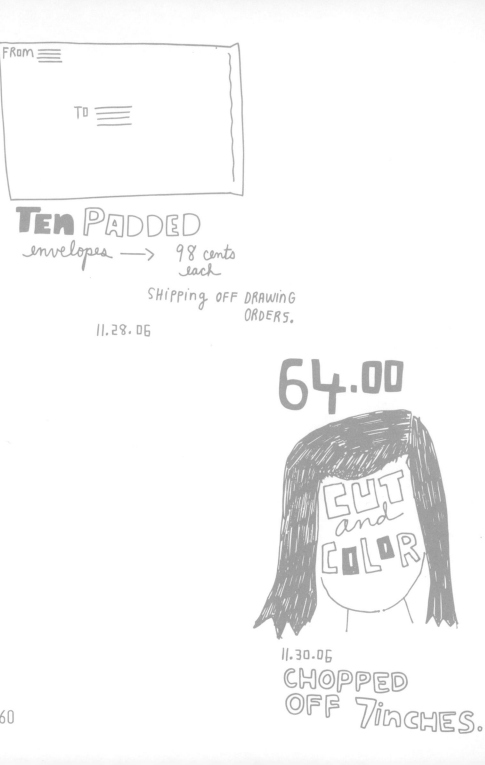

**TEN** PADDED
envelopes ⟶ 98 cents
each

SHIPPING OFF DRAWING
ORDERS.

11.28.06

64.00

CUT
and
COLOR

11.30.06
CHOPPED
OFF 7inches.

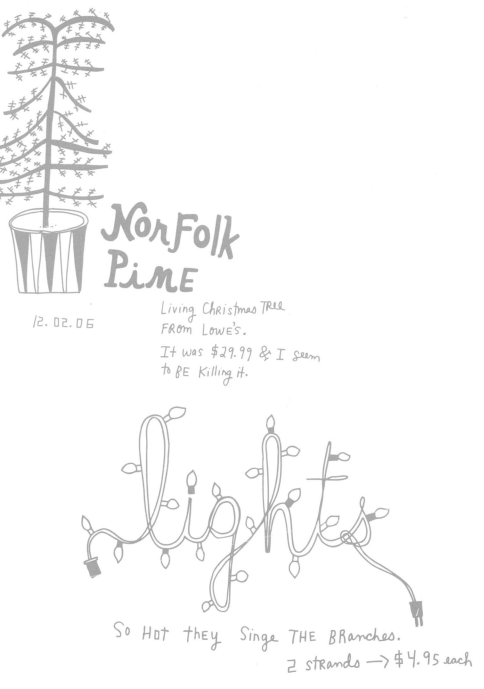

# NorFolk PiNE

12.02.06

Living Christmas TREE FROM LOWE'S.
It was $29.99 & I seem to BE Killing it.

## lights

So HOT theY SiNge THE BRanches.
2 strands → $4.95 each

12.03.06

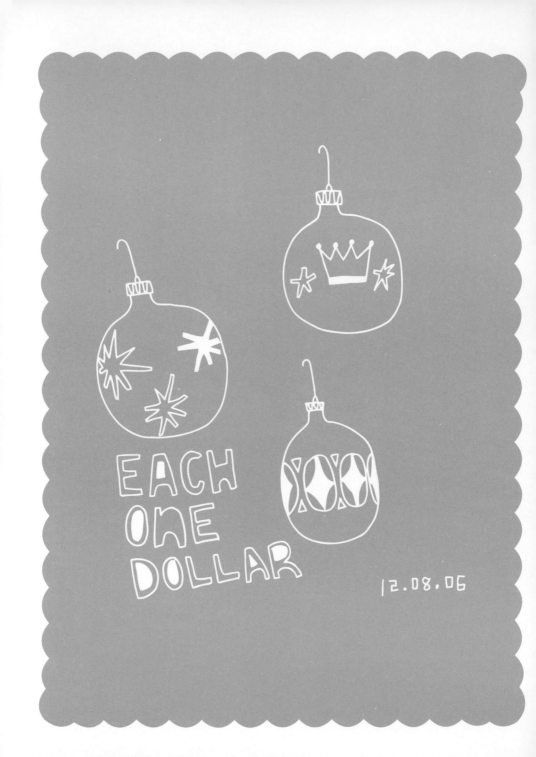

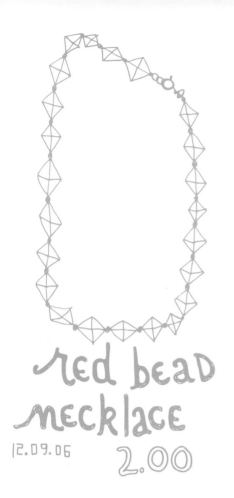

red bead
necklace
12.09.06          2.00

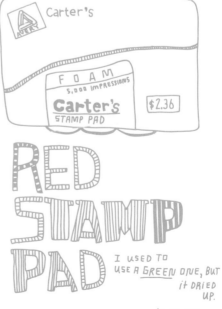

Carter's

AVERY

FOAM
5,000 IMPRESSIONS
Carter's
STAMP PAD

$2.36

RED
STAMP
PAD    I USED TO
USE A *GREEN* ONE, BUT
        it DRIED
          UP.

12.10.06          63

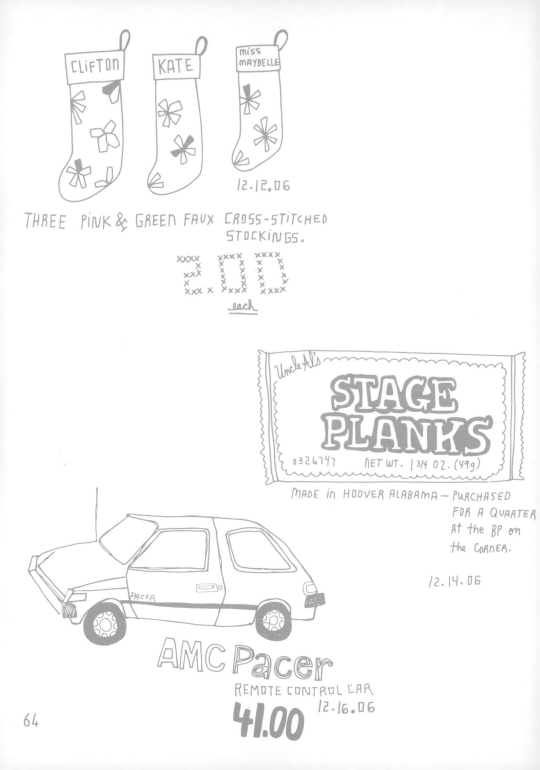

CLIFTON  KATE  miss MAYBELLE

12.12.06

THREE PINK & GREEN FAUX CROSS-STITCHED STOCKINGS.

3.00

each

*Uncle Al's*

**STAGE PLANKS**

0326747    NET WT. 1 3/4 OZ. (49g)

MADE IN HOOVER ALABAMA — PURCHASED FOR A QUARTER AT THE BP on the CORNER.

12.14.06

PACER

AMC Pacer

REMOTE CONTROL CAR

12.16.06

41.00

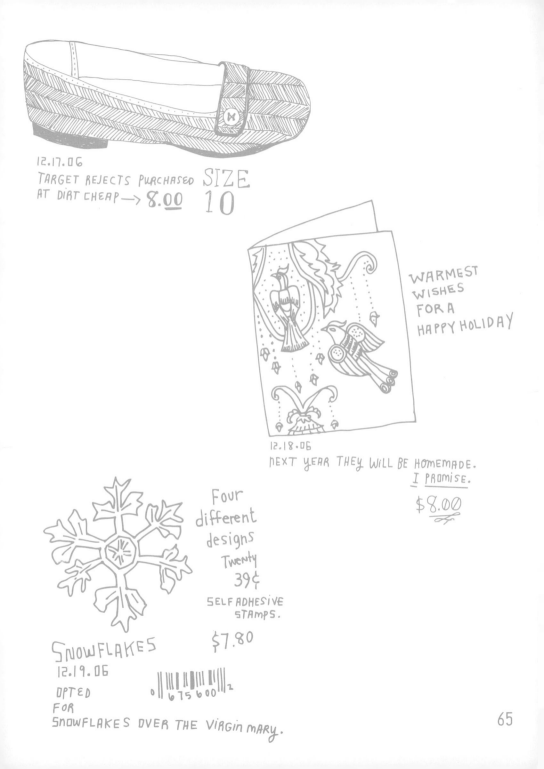

12.17.06
TARGET REJECTS PURCHASED SIZE
AT DIRT CHEAP → 8.00   10

WARMEST
WISHES
FOR A
HAPPY HOLIDAY

12.18.06
NEXT YEAR THEY WILL BE HOMEMADE.
I PROMISE.

$8.00

Four
different
designs
Twenty
39¢
SELF ADHESIVE
STAMPS.

$7.80

SNOWFLAKES
12.19.06

OPTED
FOR
SNOWFLAKES OVER THE VIRGIN MARY.

0 675600 2

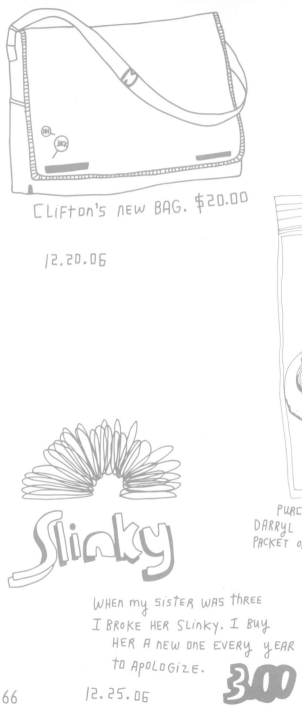

CLifton's new BAG. $20.00

12.20.06

RUN DMC
by. Nathan Mckee

12.22.06
PURCHASED FROM NEEDLES & PENS.
DARRYL "DMC" McDaniels is missing FROM TH
PACKET OF PINS... HE LIVES ON MY COAT NOW.

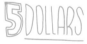
5 DOLLARS

Slinky

WHEN MY SISTER WAS THREE
I BROKE HER SLINKY. I BUY
   HER A NEW ONE EVERY YEAR
      TO APOLOGIZE.
                       300

12.25.06

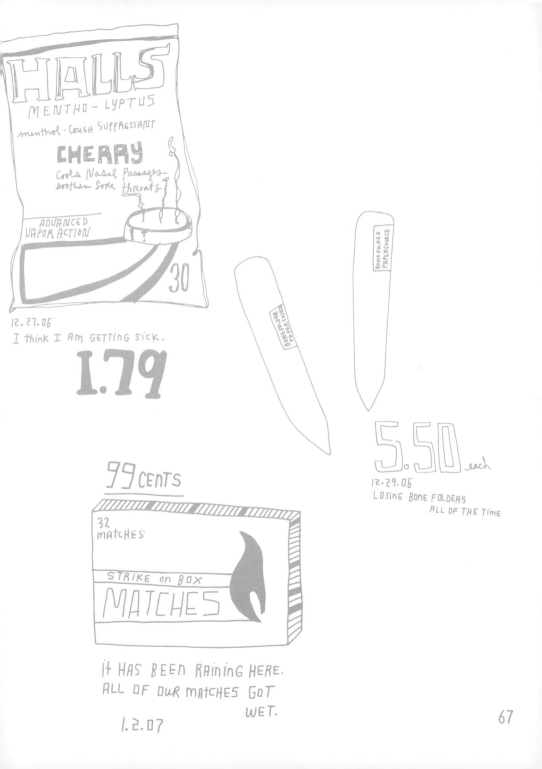

**HALLS**
MENTHO - LYPTUS
menthol · COUGH SUPPRESSANT
**CHERRY**
Cools Nasal Passages
soothes sore throats
ADVANCED VAPOR ACTION
30

12.27.06
I think I am GETTING SICK.

**1.79**

BONE FOLDER PAPERSOURCE

BONE FOLDER PAPERSOURCE

**5.50** each
12.29.06
LOSING BONE FOLDERS
ALL OF THE TIME

**99 CENTS**

32 MATCHES
STRIKE on BOX
**MATCHES**

IT HAS BEEN RAINING HERE.
ALL OF OUR MATCHES GOT
WET.

1.2.07

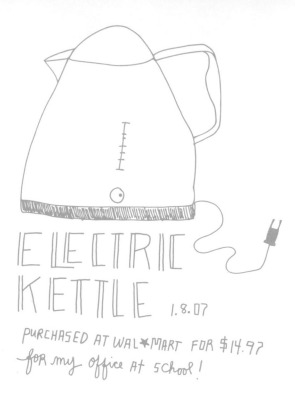

# E LE CTRIC
# KETTLE  1.8.07

PURCHASED AT WAL★MART FOR $14.97
for my office At 5chool !

METALLIC GOLD
Non-PHOTO BLUE
METALLIC SILVER
Sienna Brown
Pink
TRUE BLUE
APPLE GReen

# SEVEN
# COLOR
# PENCILS
# 27CENTS
75% off
1.9.07

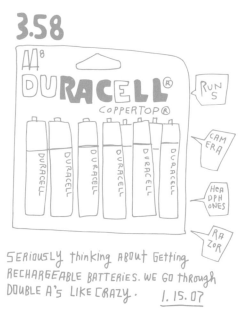

**3.58**

AA⁸
# DURACELL ®
COPPERTOP ®

RUN S

CAM ERA

HEA DPH ONES

RA ZOR

SERIOUSLY thinking ABout Getting
RECHARGEABLE BATTERIES. WE GO THROUGH
DOUBLE A's LIKE CRAZY.  1.15.07

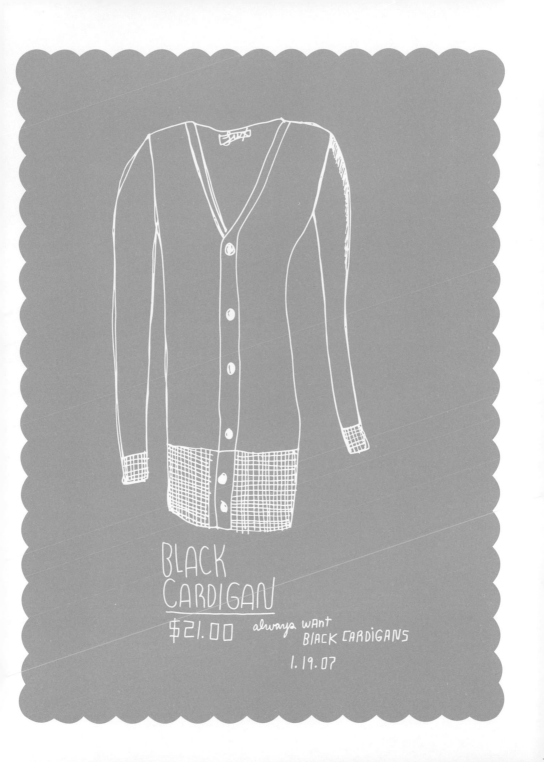

# FROM AN

# AIRPORT

# LUNCH

## TO A VINTAGE

# WRITING

# DESK

EMENT

| BALANCE | Payment Due Date | PAST DUE Amount | minimum Payment |
|---|---|---|---|
| 834.52 | 07/20/07 | $0 00 | $16 00 |

**CHASE**

AMOUNT ENCLOSED  $

make your check payable to chase card services
New address or e mail? PRINT ON BACK

I want to purchase optional
Payment Protector Plan. *
I have read the enclosed offer
& may cancel any time

_____   _____
Initials                      Date

2180732142081245678000000

KATE BINGAMAN
PO BOX 455
MISSISSIPPI STATE, MS 39762

CARDMEMBER SERVICE
PO BOX 94014
PALATINE IL 60094-4014

**CHASE**

| opening/closing Date | 05/27/07 → 06/26/07 |
|---|---|
| Payment DUE Date | 07/20/07 |
| minimum Payment Due | $16.00 |

CUSTOMER SERVICE
In U.S.   1 800·945·2000
Espanol  1·888 446·3308
TDD      1 800·955·8060
Pay By phone 1·800·436 7958
OUTSIDE U.S. call collect
          1·302·594·8200

## MASTERCARD ACCOUNT SUMMARY

| | | | |
|---|---|---|---|
| Previous Balance | $425 44 | Total Credit Line | $21,500 |
| Payment, Credits | - $50.00 | Available Credit | $20,665 |
| Purchases, Cash, Debits | + 450.43 | Cash Access Line | $21,500 |
| Finance Charges | + $8.65 | Available for Cash | $20,665 |
| | $834 52 | | |

ACCOUNT INQUIRIES
PO BOX 15248
Wilmington, DE 19850·529

PAYMENT ADDRESS
P.O. BOX 94014
Palatine, IL 60094-4014

VISIT US AT:
www.chase.com/creditc

## TRANSACTIONS

| TRANS DATE | REF NUMBER | MERCHANT NAME/TRANS DESCRIPTION | Amount CREDIT/DEB |
|---|---|---|---|
| 06/09 | | PAYMENT — THANK YOU | $50.00 |

## FINANCE CHARGES

$865

| Category | Daily Periodic Rate Corresp 28 DAYS in cycle APR | | AVERAGE DAILY Balance | Finance Charge DUE TO PERIODIC RATE | TRansaction Fee | Accumulated Fin Charge | FINANC CHARGE |
|---|---|---|---|---|---|---|---|
| Purchases | V .04587% | 16 74% | $1673 34 | $8.65 | $0.00 | $0.00 | $8.65 |
| Cash Advances | V .05683% | 20 74% | $0.00 | $0.00 | $0.00 | $0.00 | $0.00 |
| Total Finance charges | | | | | | | $8 65 |

Effective Annual Percentage Rate (APR): 16.74%

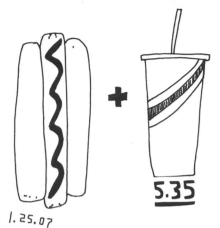

1.25.07

WHEN I AM AT
THE AIRPORT I EAT LIKE
A KING!
ATLANTA, GA

5.35

5.96

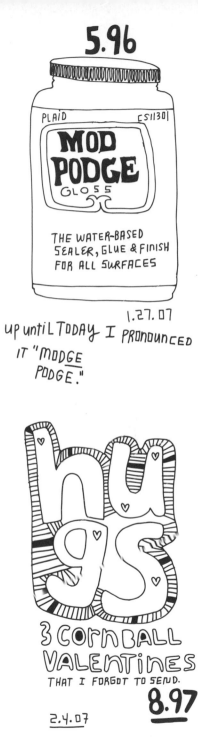

PLAID                CS11301

MOD
PODGE
GLOSS

THE WATER-BASED
SEALER, GLUE & FINISH
FOR ALL SURFACES

1.27.07

UP UNTIL TODAY I PRONOUNCED
IT "MODGE
PODGE."

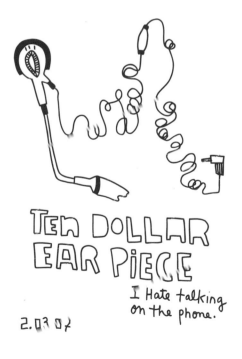

TEN DOLLAR
EAR PIECE

I HATE talking
on the phone.

2.03.07

hugs

3 CORNBALL
VALENTINES
THAT I FORGOT TO SEND.

8.97

2.4.07

73

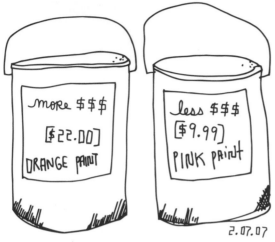

more $$$

[$22.00]

ORANGE PAINT

less $$$

[$9.99]

PINK PAINT

2.07.07

FOR THE WALLS @
    THE PAPER BOAT.

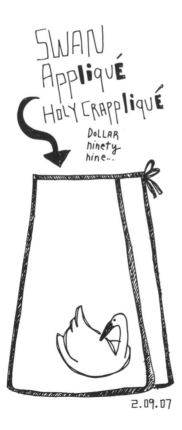

SWAN
APPLIQUÉ
HOLY CRAPPLIQUÉ

Dollar
ninety
nine...

2.09.07

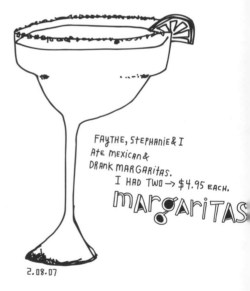

FAYTHE, STEPHANIE & I
ATE MEXICAN &
DRANK MARGARITAS.
    I HAD TWO → $4.95 EACH.
margaritas

2.08.07

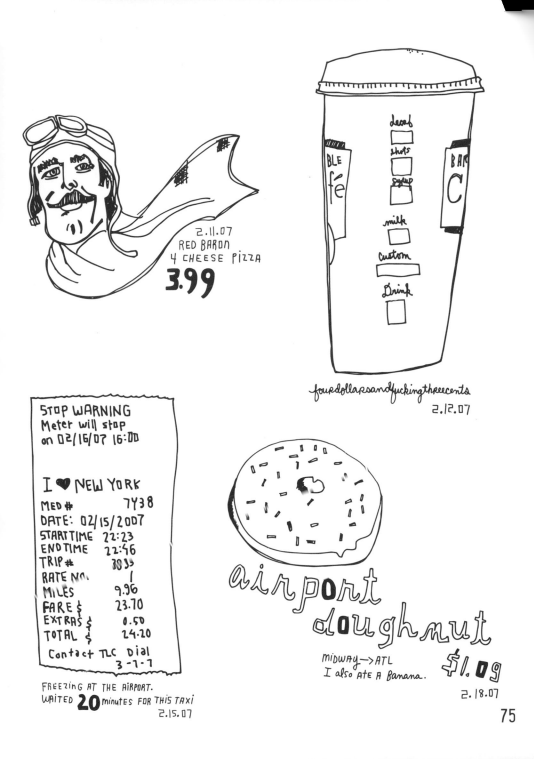

2.11.07
RED BARON
4 CHEESE PIZZA
**3.99**

decaf
shots
syrup
BLE
fé
BAR
C
milk
custom
Drink

fourdollarsandfuckingthreecents
2.12.07

STOP WARNING
Meter will stop
on 02/16/07 16:00

I ♥ NEW YORK

MED # 7438
DATE: 02/15/2007
START TIME 22:23
END TIME 22:46
TRIP # 3035
RATE NO. 1
MILES 9.96
FARE $ 23.70
EXTRAS $ 0.50
TOTAL $ 24.20
Contact TLC Dial
3-7-7

FREEZING AT THE AIRPORT.
WAITED **20** minutes FOR THIS TAXI
2.15.07

airport
doughnut
MIDWAY→ATL
I also ATE A Banana.
**$1.09**
2.18.07

75

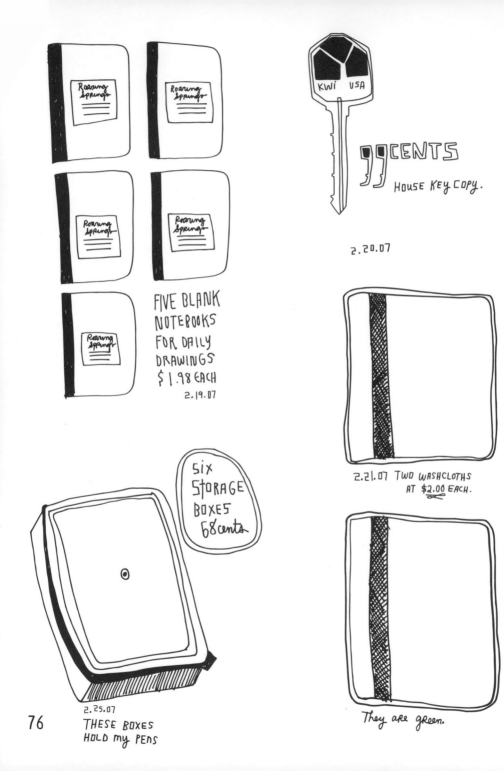

FIVE BLANK
NOTEBOOKS
FOR DAILY
DRAWINGS
$1.98 EACH
2.19.07

99CENTS
HOUSE KEY COPY.

2.20.07

2.21.07 TWO WASHCLOTHS
AT $2.00 EACH.

SIX
STORAGE
BOXES
68cents

2.25.07
THESE BOXES
HOLD MY PENS

They are green.

76

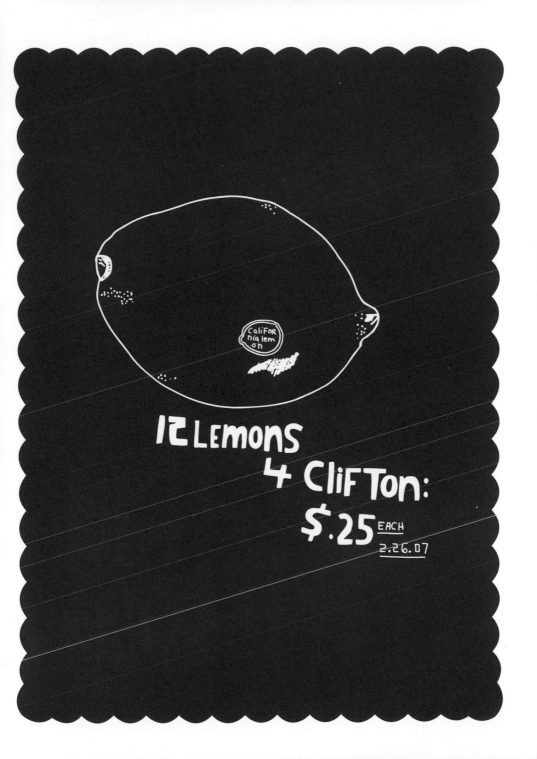

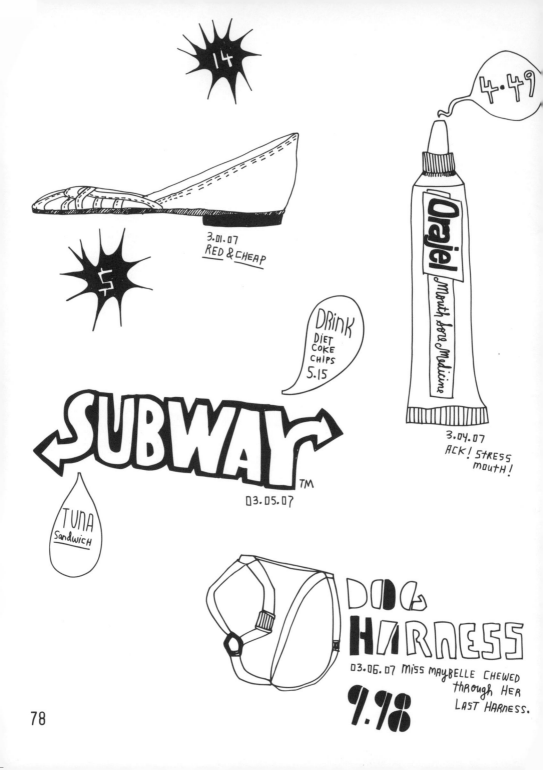

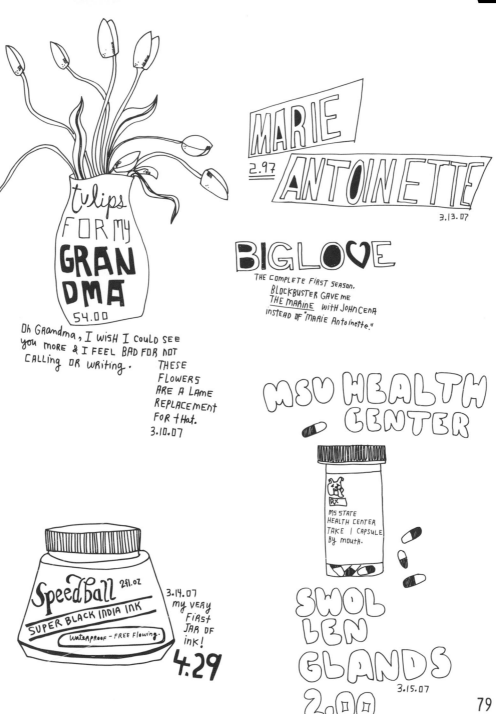

tulips FOR MY **GRAN DMA** 54.00

Oh Grandma, I wish I could see you more & I feel bad for not calling or writing. THESE FLOWERS ARE A LAME REPLACEMENT FOR tHat. 3.10.07

MARIE 2.97 ANTOINETTE 3.13.07

BIGLOVE THE COMPLETE FIRST SEASON. BLOCKBUSTER GAVE ME THE MARINE with John Cena instead of "MARIE Antoinette."

MSU HEALTH CENTER

MS STATE HEALTH CENTER TAKE 1 CAPSULE BY MOUTH.

SWOL LEN GLANDS 3.15.07 2.00

Speedball 2fl.oz 3.14.07 SUPER BLACK INDIA INK WaterPROOF - FREE Flowing. my very First JAR of ink! 4.29

79

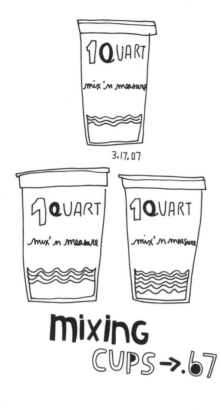

**mixing**
CUPS →.67

3.17.07

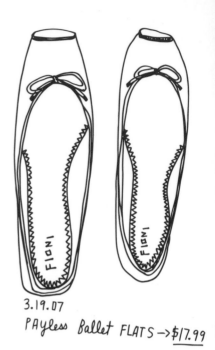

3.19.07
PAYless Ballet FLATS → $17.99

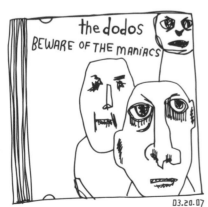

the dodos
BEWARE OF THE MANIACS

03.20.07

WILL PICKED THIS UP
FOR ME AT SXSW.
$10.00

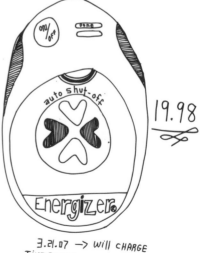

on/off    done

auto shut-off

19.98

Energizer.

3.21.07 → WILL CHARGE
TIVO REMOTE, WIRELESS HEADPHONES
& MY CAMERA. GO BATTERY CHARGER!

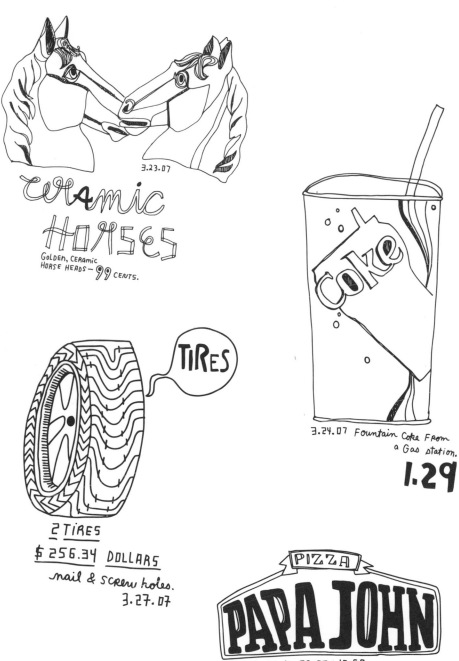

3.23.07

**ceRAmic HORSES**

GoLDEN, CERAMic
HORSE HEADS — 99 CENTS.

TiRes

3.24.07 Fountain Coke FRom
a Gas station.
**1.29**

2 TIRES
$256.34 DOLLARS
nail & screw holes.
3.27.07

PIZZA
PAPA JOHN
CHEESE THiN CRUST : 10.69

4.01.07

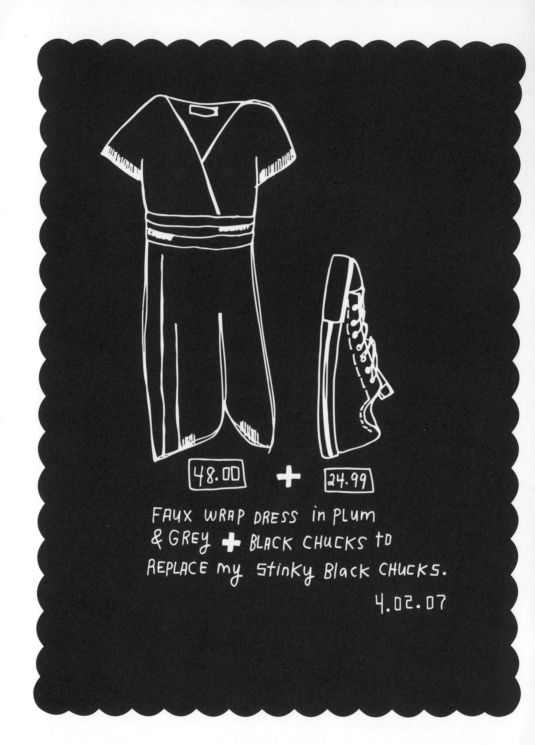

# VANITY FAIR inTouch

airport Reading material $4.50 + $1.99

4.03.07

$1.59

Diet Coke

COKE FOR ME

$1.59

Dr Pepper (23)

DR. PEPPER FOR JENNI.

**CVS** in HARTFORD, CT

4.06.07

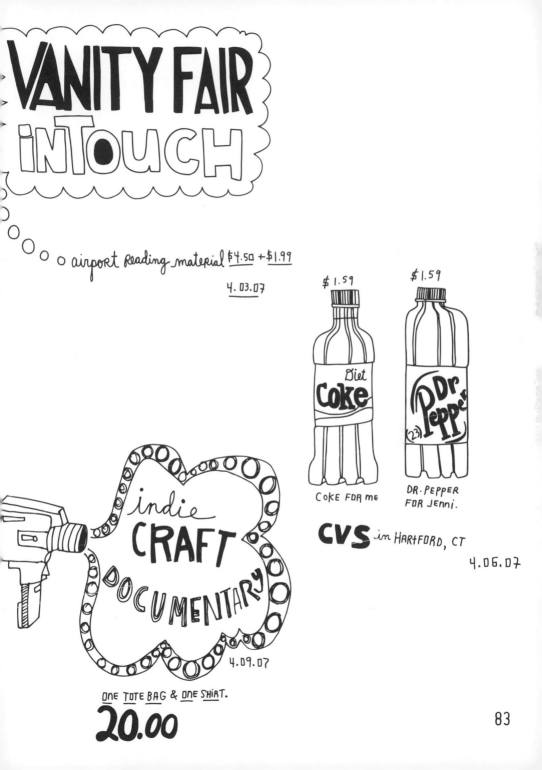

indie CRAFT DOCUMENTARY

4.09.07

ONE TOTE BAG & ONE SHIRT.
**20.00**

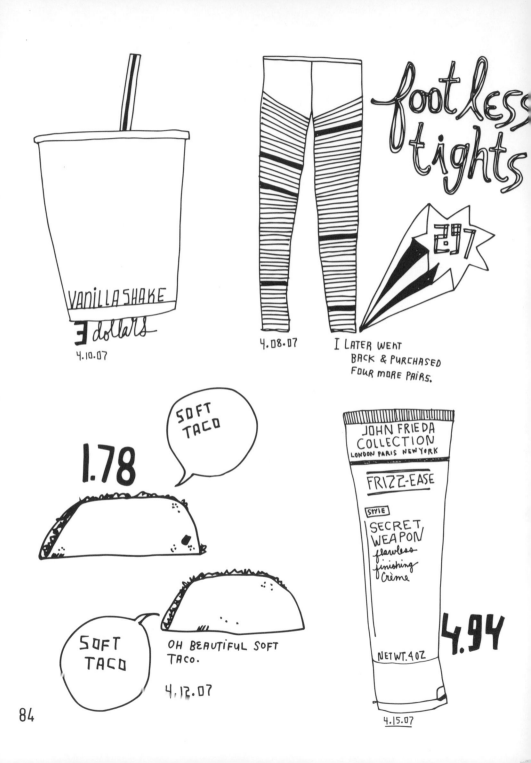

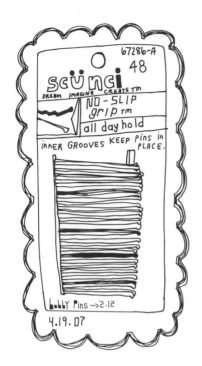

67286-A
48

scünci
DREAM   IMAGINE   CREATE ™

NO-SLIP
grip ™

all day hold

inner GROOVES KEEP PINS in PLACE.

bobby PINS → 2.12

4.19.07

minor manybelle Gren paw hunt

3M Pet Car
LIQUID BANDAGE

• FOR minor scrapes cuts, abrasions & irritations on PAWS & SKIN
• LASTS up to 24hrs

BREATHABLE

0 6 fl oz

SEVEN DOLLARS
ninety EIGHT
cents

4.20.07

# Walgreens
### SUNGLASSES

* * *
* *
*
*

4.21.07
THEY SLIP OFF
my FACE.

**4.00**

**75%**
OFF

12
11   1
10   TIMEX   2
9         3
8   INDIGLO   4
7   6   5

# my
# FAVO
# RITE
### WATCH EVER.
$20.00
4.22.07

85

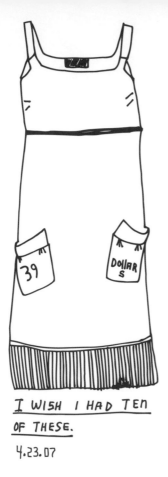

I WISH I HAD TEN
OF THESE.
4.23.07

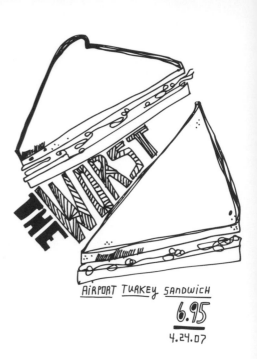

AIRPORT TURKEY SANDWICH
6.95
4.24.07

**2.50 x 4 = 10.00**

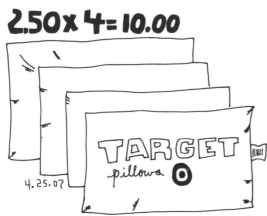

TARGET
pillows

4.25.07

PROPS FOR A GALLERY
INSTALLATION — CHICAGO.

Sultan's
Market
NORTH AVE
LENTIL SOUP: $2
FALAFEL: $3
AWESOME: $5

4.26.07
I COULD EAT HERE EVERY DAY

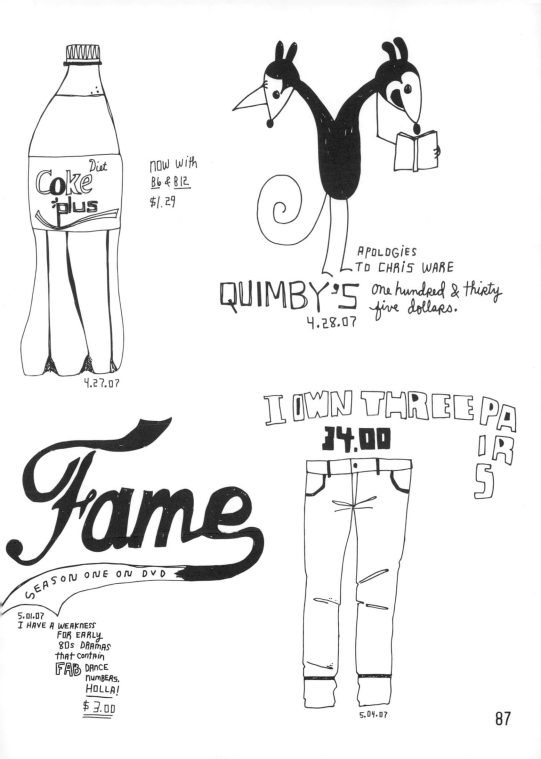

Diet Coke plus

now with B6 & B12
$1.29

4.27.07

APOLOGIES TO CHRIS WARE

QUIMBY'S
4.28.07

one hundred & thirty five dollars.

Fame
SEASON ONE ON DVD

5.01.07
I HAVE A WEAKNESS FOR EARLY 80s DRAMAS that contain FAB DANCE numbers. HOLLA!

$ 3.00

I OWN THREE PAIRS
34.00

5.04.07

87

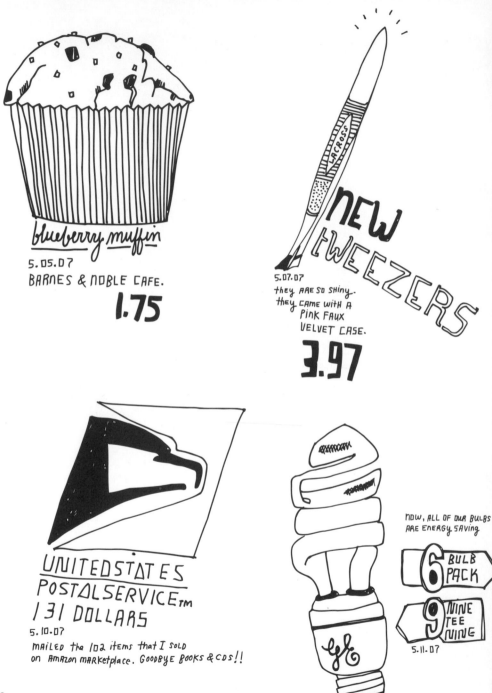

blueberry muffin
5.05.07
BARNES & NOBLE CAFE.
1.75

NEW tweezers
5.07.07
they ARE SO SHiny.
they CAME WiTH A
PiNK FAUX
VELVET CASE.
3.97

LACROSS

UNITED STATES
POSTAL SERVICE™
131 DOLLARS
5.10.07
MAiLED the 102 items that I SOLD
on AMAzon MARKetplace. GOODBYE BOOKS & CDS!!

NOW, ALL OF OUR BULBS
ARE ENERGY SAVING

6 BULB PACK
9 NINE TEE NINE
5.11.07

GE

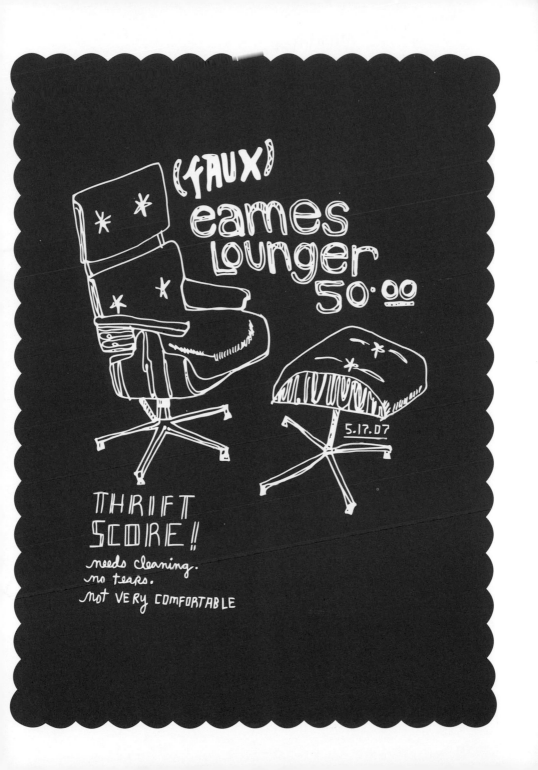

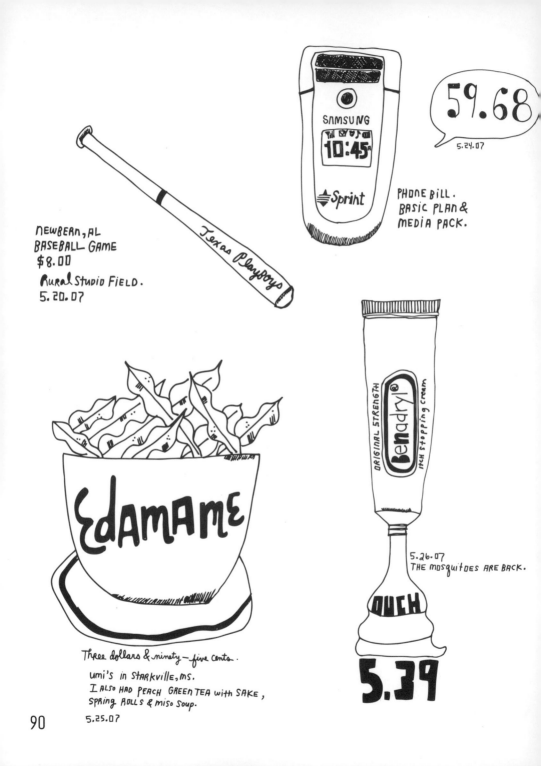

59.68
5.24.07

PHONE BILL.
BASIC PLAN &
MEDIA PACK.

NEWBERN, AL
BASEBALL GAME
$8.00
Rural Studio Field.
5.20.07

*Texas Playboys*

ORIGINAL STRENGTH
Benadryl®
itch stopping cream

5.26.07
THE MOSQUITOES ARE BACK.

OUCH

5.39

Edamame

Three dollars & ninety-five cents.

umi's in STARKVILLE, MS.
I ALSO HAD PEACH GREEN TEA with SAKE,
SPRING ROLLS & miso Soup.
5.25.07

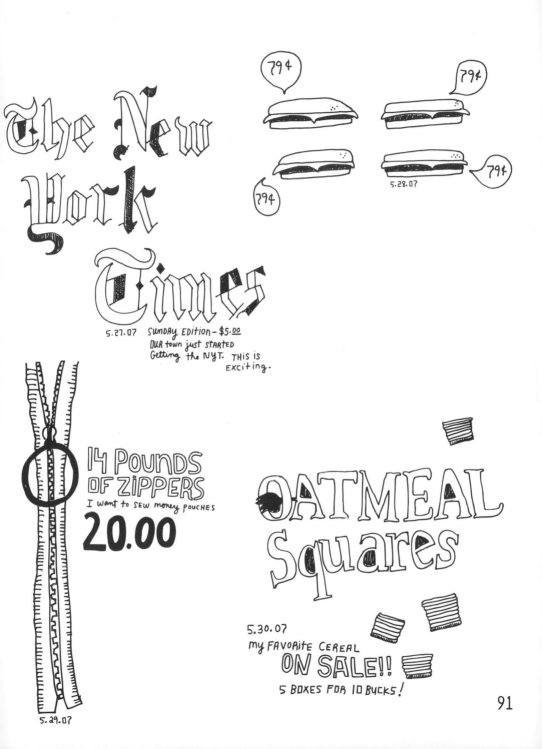

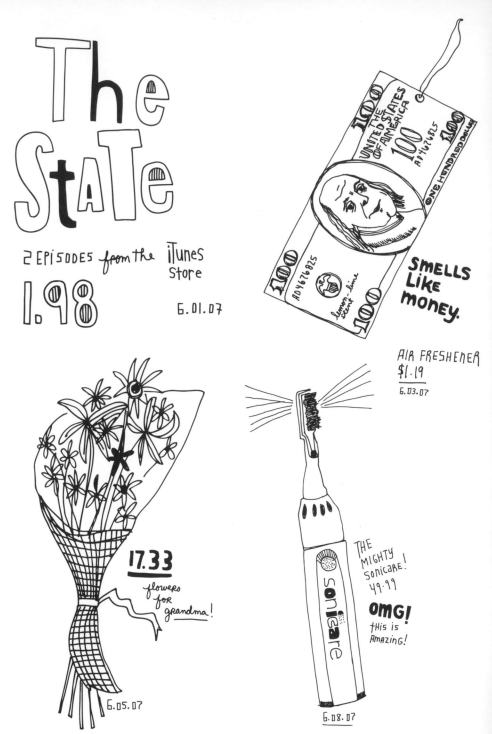

The State

2 EPISODES from the iTunes Store
1.98
6.01.07

SMELLS LIKE MONEY.

AIR FRESHENER
$1.19
6.03.07

17.33
flowers for grandma!
6.05.07

THE MIGHTY SONICARE!
49.99
OMG!
this is AMAZING!

sonicare

6.08.07

92

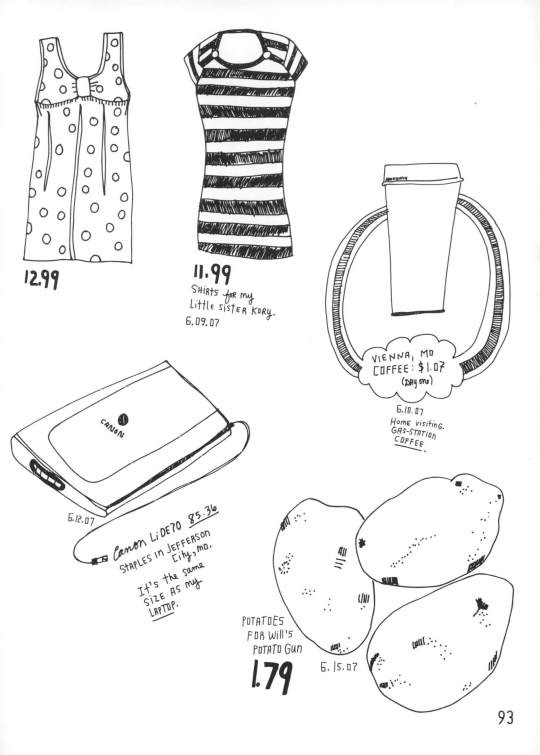

12.99

11.99
Shirts for my
Little sister Kory.
6.09.07

VIENNA, MO
COFFEE: $1.07
(DAY one)
6.10.07
Home visiting.
GAS-STATION
COFFEE.

CANON

6.12.07
Canon LiDE70 85.36
STAPLES IN JEFFERSON
City, mo.
It's the same
size as my
LAPTOP.

POTATOES
FOR Will's
POTATO Gun
1.79
6.15.07

93

CENTRAL CITY BINGO CARDS
6.16.07
I also
PURCHASED A BUNCH
        OF FABRIC & GOLD
        RICK-RACK.

.25

PEG BOARD
6.98
new BOARD FOR my studio.
6.27.07

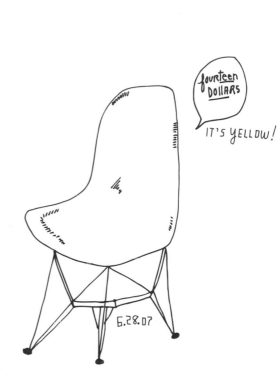

fourteen DOLLARS

IT'S YELLOW!

6.28.07

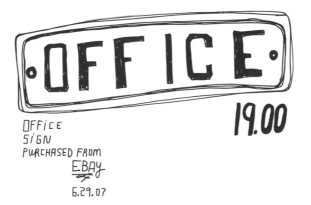

OFFICE
sign
PURCHASED FROM
EBAY
6.29.07

19.00

95

nine BOXE
2.98 EACH

MeBOX

6.30.07

THE MAGNETIC FIELDS

**69**

7.02.07

I HAVE BOUGHT THIS BOX SET
THREE TIMES. ARGH! Where DO I LOSE them?

# 29.99

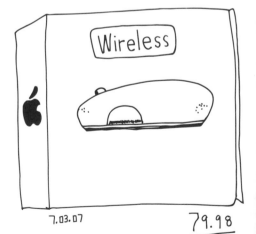

Wireless

7.03.07

79.98

THIS Didn't WORK nearly AS
WELL AS I thought it would.

# BUNDLE OF FABRIC

BUNDLE OF FABRIC
FROM ETSY → 20.00

Samples of Patterns.
7.04.07

♡ SWEET ♥

# EXPRESS OIL CHANGE

54.76 ⊕ WIPERS
7.06.07

REEVES
Gouache
Leaf Green

POSSIBLY CRAPPY GOUACHE →
$9.98
for 18 tubes.
7.07.07

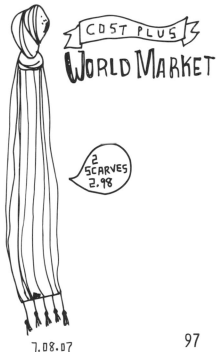

COST PLUS
WORLD MARKET

2
SCARVES
2.98

7.08.07

97

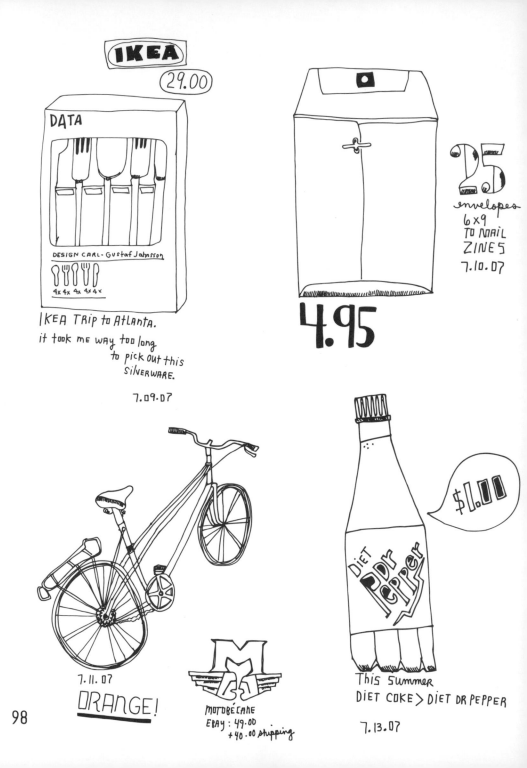

IKEA

29.00

DATA

DESIGN CARL-Gustaf Johnsson

4x 4x 4x 4x 4x

IKEA TRIP to Atlanta.
it took me way too long
to pick out this
silverware.

7.09.07

25 envelopes
6 x 9
TO MAIL
ZINES
7.10.07

4.95

7.11.07
ORANGE!

MOTOBÉCANE
EBAY: 49.00
+40.00 shipping

$1.00

DiET Dr Pepper

This Summer
DIET COKE > DIET DR PEPPER

7.13.07

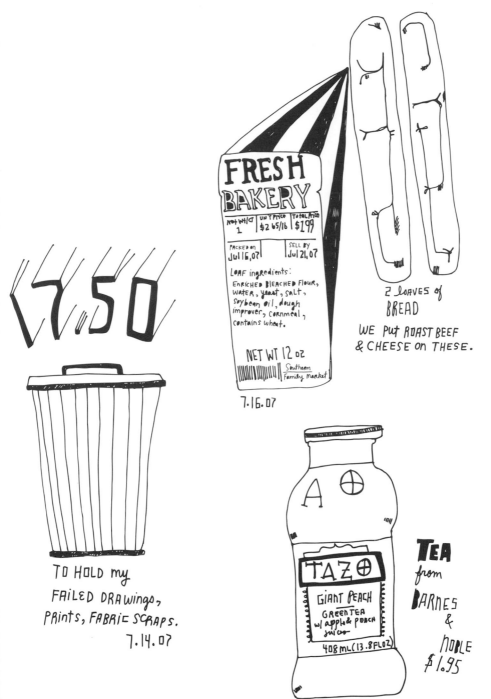

(7.50

TO HOLD my
FAILED DRAWings,
PRints, FABRIC SCRAPS.
7.14.07

FRESH
BAKERY

| Net Wt/Ct | Unit Price | Total Price |
| 1 | $2.65/lb | $1.99 |

| PACKED ON | SELL BY |
| Jul 16,07 | Jul 21,07 |

LOAF ingredients:
ENRICHED BLEACHED FLOUR,
WATER, yeast, salt,
soybean oil, dough
improver, cornmeal,
contains wheat.

NET WT 12 oz

Southern
Family Market

7.16.07

2 loaves of
BREAD

WE Put ROAST BEEF
& CHEESE on THESE.

A ⊕

TAZ⊕

GIANT PEACH

GREEN TEA
w/ apple & peach
juices

408 mL (13.8 FL OZ)

TEA
from
BARNES
&
NOBLE
$1.95

7.17.07

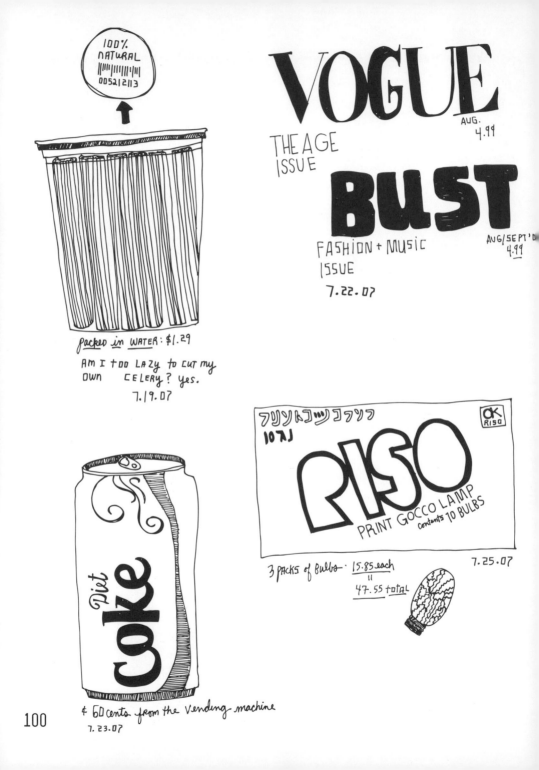

100% NATURAL

005212113

packed in WATER: $1.29

AM I too LAzy to cut my
own CELERY? yes.

7.19.07

VOGUE
AUG.
4.99

THE AGE
ISSUE

BUST

FASHION + MUSIC
ISSUE

AUG/SEPT'D
4.99

7.22.07

フリントゴッコランフ
10ズ

RISO
PRINT GOCCO LAMP
Contents 10 BULBS

OK
RISO

3 packs of Bulbs · 15.85 each
"
47.55 total

7.25.07

Diet Coke

# 60 cents from the vending machine
7.23.07

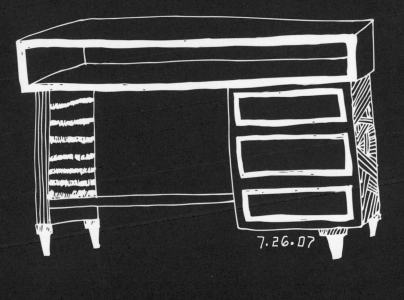

# FROM A HAIRCUT TO SUPER FANCY TWEEZERS

ISSUE BY BARCLAYS BANK

| | |
|---|---|
| MIN PAYMENT DUE | $138.00 |
| PAYMENT DUE DATE | AUGUST 18th, 200 |
| CURRENT BALANCE | $4,585. |

AMOUNT ENCLOSE

☐  check for address ch
complete form on the

Illilliuu lli.lllluu lliu ill uu luulullulliuu lu llu.lu.llul
JUNIPER BANK
PO·BOX 13337
PHILADELPHIA, PA 19101-3337

KATE BINGAMAN
PO BOX 455
MISSISSIPPI STATE MS 39762

## Account Summary

| | |
|---|---|
| Payment DUE Date | AUGUST 18th, 2007 |
| Minimum Payment DUE | $138.00 |
| Credit Line | $16,050 |
| Credit Available | $11,464.03 |
| Over Credit Line Amount | $0.00 |
| Cash Credit Line | $16,420 |
| Cash Credit Available | $16,420 |
| Past Due Amount | $0.00 |

Statement Closing Date 7.24

| | | |
|---|---|---|
| Previous Balance | | $4,488.42 |
| Payments & CREDITS | − | $135.00 |
| PURCHASES | + | $190 46 |
| Cash Advances | + | $0.00 |
| Balance TRANSFERS/CHECKS | + | $0 00 |
| SERVICE CHARGES | + | $0 00 |
| FINANCE CHARGES | + | $42. |
| CURRENT BALANCE | = | $4,585 |

## TRANSACTION Activity: KATE BINGAMAN

| payments | DATE | TRANSACTION DESCRIPTION | AMOUNT |
|---|---|---|---|
| | 07/20 | payment Received    NATL BK | − $135.00 |

## FINANCE CHARGE SUMMARY

| | Average Daily Balance | Periodic RATE | Corresponding ANNUAL PERCENTAGE RATE | FINANCE CHARGE |
|---|---|---|---|---|
| PURCHASES | $4,146.91 | 0.0335% | 12.24% | $40 29 |
| BALANCE TRANSFERS/CHECKS | $0.00 | 0.0335% | 12.24% | $0.00 |
| CASH ADVANCE | $0.00 | 0.0664% | 24 24% | $0.00 |
| Bal Trans/Check Incentive | $378 35 | 0.0164% | 5.99% | $1.80 |

| Effective ANNUAL PERCENTAGE RATE | 11.16% |
|---|---|

The effective APR represents your total FINANCE charges — including transaction fees such as cash Advances & balance transfer FEES — expressed AS A percentage.

new haircut : 36.00
8.08.07

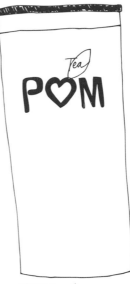

POMEGRANATE
PEACH PASSION WHITE
TEA ♡
$1.98

8.09.07

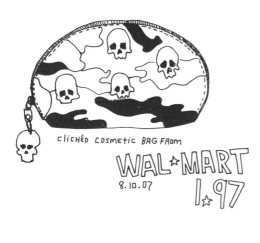

CLICHÉD COSMETIC BAG FROM

WAL★MART
8.10.07
1.97

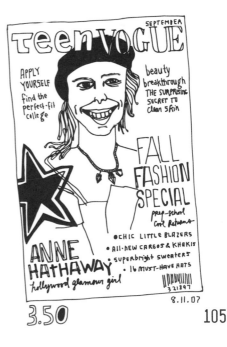

teenVOGUE

SEPTEMBER

APPLY
YOURSELF
find the
perfect-fit
college

beauty
breakthrough
THE SURPRISING
SECRET TO
clean skin

FALL
FASHION
SPECIAL

prep-school
cool returns

● CHIC LITTLE BLAZERS
● ALL-NEW CARGOS & KHAKIS
● SUPERBRIGHT SWEATERS
● 16 MUST-HAVE HATS

ANNE
HATHAWAY
hollywood glamour girl

3 21897

8.11.07

3.50

105

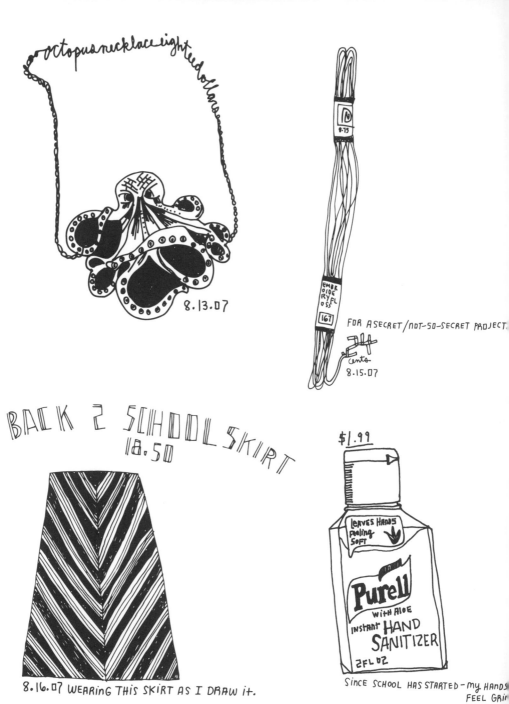

octopus necklace eighteed dollars 8.13.07

For a secret/not-so-secret project.
cents
8.15.07

BACK 2 SCHOOL SKIRT
18.50

8.16.07 WEARING THIS SKIRT AS I DRAW it.

$1.99

LEAVES HANDS feeling SOFT

Purell
WITH ALOE
INSTANT HAND SANITIZER
2FL OZ

SINCE SCHOOL HAS STARTED - MY HANDS
FEEL GRIM
ALL OF TH
Tim
8.21.0

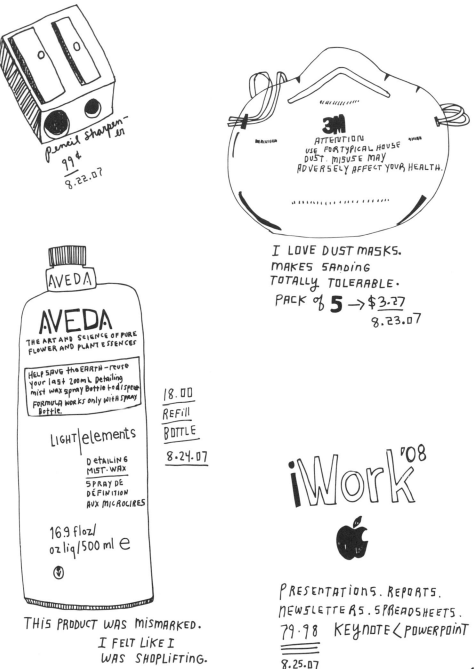

Pencil Sharpener
99¢
8.22.07

3M
ATTENTION
USE FOR TYPICAL HOUSE
DUST. MISUSE MAY
ADVERSELY AFFECT YOUR HEALTH.

I LOVE DUST MASKS.
MAKES SANDING
TOTALLY TOLERABLE.
PACK of 5 → $3.27
8.23.07

AVEDA
AVEDA
THE ART AND SCIENCE OF PURE
FLOWER AND PLANT ESSENCES

HELP SAVE the EARTH — reuse
your last 200mL Detailing
mist wax spray Bottle to dispense
FORMULA WORKS only WITH spray
Bottle.

LIGHT elements

Detailing
MIST·WAX
SPRAY DE
DÉFINITION
AUX MICROCIRES

16.9 fl oz/
oz liq/500 ml ℮

18.00
Refill
BOTTLE
8.24.07

THIS PRODUCT WAS MISMARKED.
I FELT LIKE I
WAS SHOPLIFTING.

iWork '08

PRESENTATIONS. REPORTS.
NEWSLETTERS. SPREADSHEETS.
79.98   KEYNOTE < POWERPOINT
8.25.07

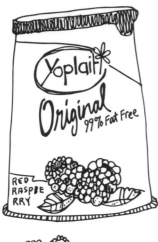

Yoplait
Original
99% Fat Free

RED RASPBE RRY

**50** cents

I REMEMBER WHEN
my little sister would
ONLY EAT YOGURT FROM
the AGES OF 6-12.
8.26.07

1.78

BEAN BURRITOS

9.02.07

no onions PLEASE.

3"
76.2mm

Bristle Blend
made in china
LOWE'S # 109125
1.59 dollars

9.06.07

EINSTEIN BROS®
Hot Fresh
BAGELS every day

asiago cheese bagel
&
chicken noodle
soup 5.62
9.05.07

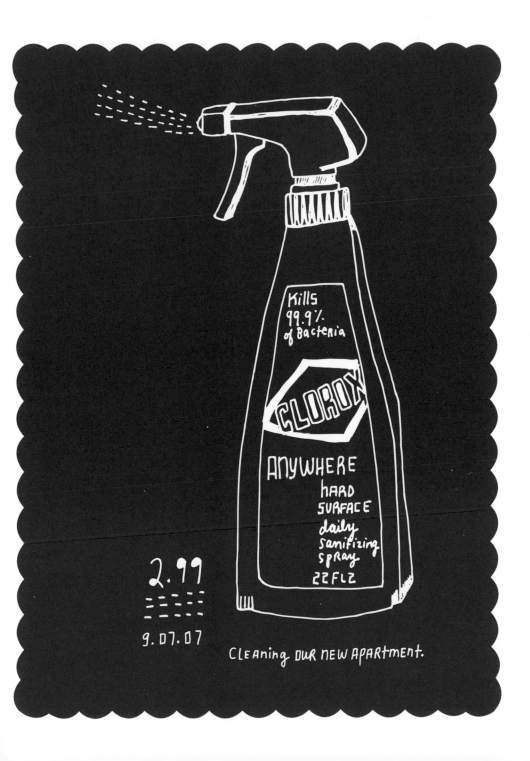

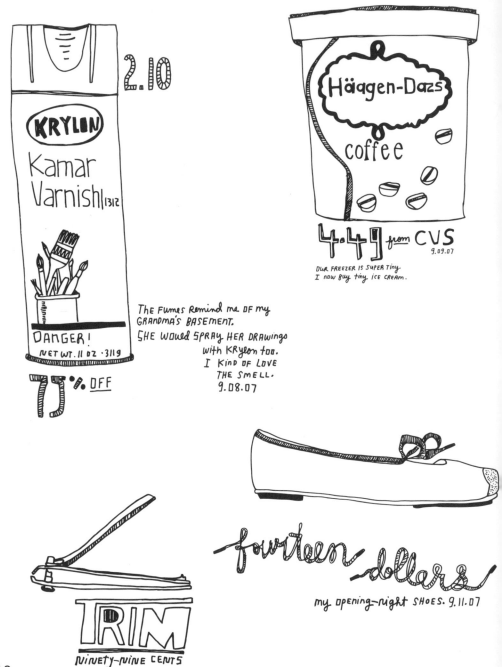

**2.10**

KRYLON
Kamar
Varnish 1312

DANGER!
NET WT. 11 OZ · 311g

**75 % OFF**

The fumes remind me of my
GRANDMA'S BASEMENT.
SHE WOULD SPRAY HER DRAWINGS
with KRYLON too.
I KIND OF LOVE
THE SMELL.
9.08.07

Häagen-Dazs

coffee

**4.49** from CVS
9.09.07

OUR FREEZER IS SUPER Tiny.
I now Buy Tiny ICE CREAM.

*fourteen dollars*

my opening-night SHOES. 9.11.07

TRIM
NINETY-NINE CENTS
9.10.07

110

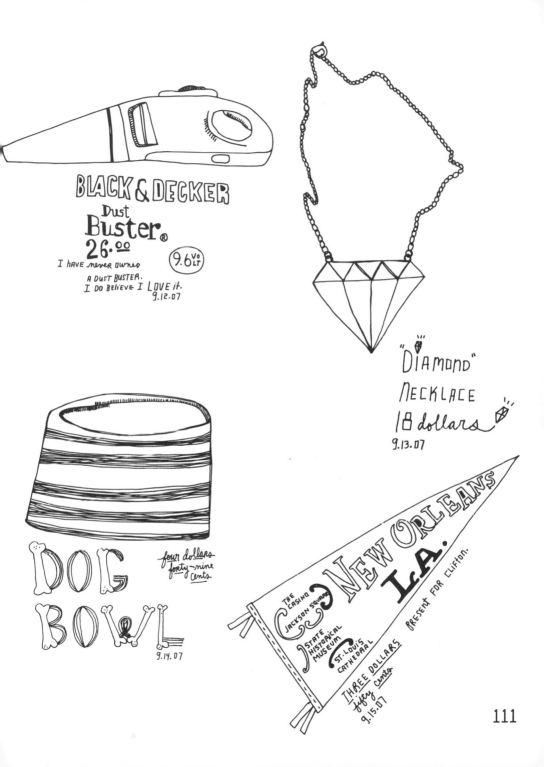

BLACK & DECKER

Dust **Buster**®
26.⁰⁰

I HAVE never owned
A DUST BUSTER.
I DO BELIEVE I LOVE it.
9.12.07

9.6 VO LT

"DIAMOND"
NECKLACE
18 dollars
9.13.07

DOG
BOWL

four dollars
forty-nine
cents

9.14.07

THE CASINO
JACKSON SQUARE
STATE HISTORICAL MUSEUM
ST. LOUIS CATHEDRAL

NEW ORLEANS
L.A.

PRESENT FOR clifton.

THREE DOLLARS
fifty cents
9.15.07

111

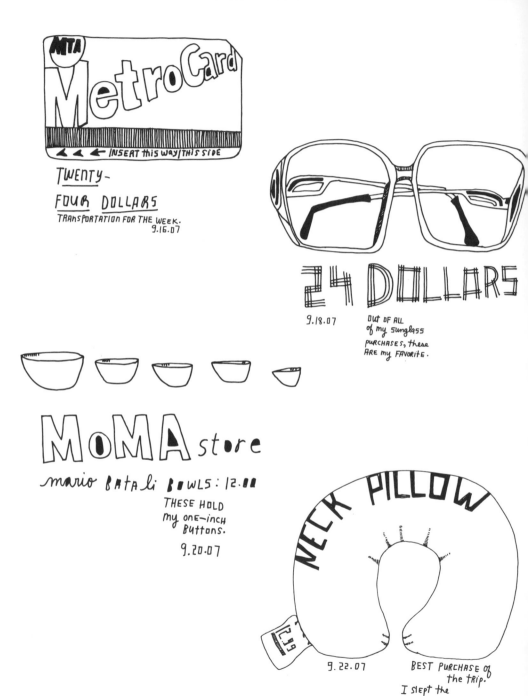

**MTA MetroCard**

◄ ◄ ← INSERT this way/THIS SIDE

TWENTY-
FOUR DOLLARS
TRANSPORTATION FOR THE WEEK.
9.16.07

**24 DOLLARS**

9.18.07

OUT OF ALL
of my sunglass
PURCHASES, these
ARE my FAVORITE.

**MoMA store**

mario BATALI BOWLS: 12.00
THESE HOLD
my one-inch
Buttons.
9.20.07

**NECK PILLOW**

12.99

9.22.07

BEST PURCHASE OF
the trip.
I slept the
whole way Home.

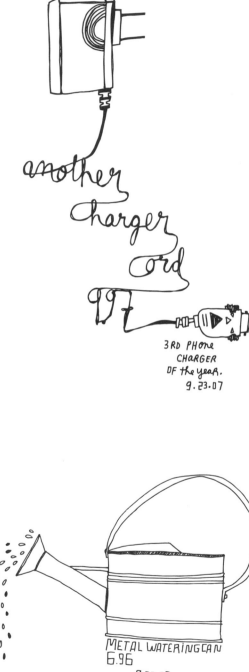

another charger cord

3RD PHONE CHARGER OF the year.
9.23.07

3.98

9.24.07 HAPPY FALL!

METAL WATERINGCAN
6.96

9.25.07

LEMON BLUEBERRY cupcake: $1.99

9.26.07

113

Energizer
9VOLT   four dollars 49/100
10.08.07

lamp from Jarvis: 19.97
10.10.07

M med.   09|85
FUTURO
SUPPORT YOUR ACTIVE LIFE
FUTURO
Energizing SUPPORT GLOVE
HAND
MASSAGING ACTION
HELPS Relieve mild HAND Discomfort
Reversible for Rt & Lt HAND
NINE DOLLARS
HOW PATHETIC is this?
10.11.07

EverStart maxx
+   −
62.28
BECAUSE my BATTERY DIED I MISSED my FACULTY MEETING. THIS DIDN'T MAKE ME TOO SAD.
10.12.07

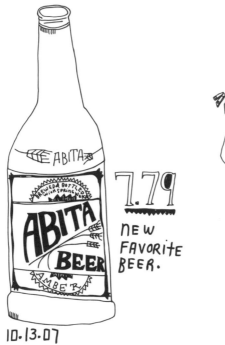

**7.79**

NEW
FAVORITE
BEER.

10.13.07

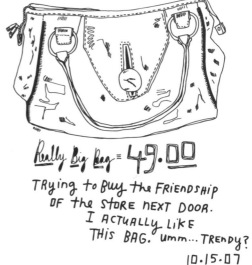

Really Big Bag = **49.00**

TRYING to BUY the FRIENDSHIP
OF the STORE NEXT DOOR.
I ACTUALLY LIKE
THIS BAG. umm... TRENDY?
10.15.07

RED
CHUNKY
RING
2.00

10.16.07
BRing on MORE BIG PLASTIC
JEWELRY !!!

BURT'S
BEES
Citrus & Ginger
BODY WASH

12 fl. oz.

**7.79**

10.17.07
Smells Good

PÄÄSYLIPPU
INTRÄDESBILJETT
TARKISTUS-
LIPPU KONTROLDEL
B
5244401
B 5244401

Entry Tickets $8.00 from KIOSK
PORI, FINLAND
10.19.07

SIX 4-FEET
GOLD TREES
FIVE DOLLARS each

FOR my upcoming
SHOW AT RAREDEVICE
10.26.07

BOP's
FROZEN CUSTARD
old fashioned ice cream
ONCE YOU BOP, YOU CAN'T STOP

three dollar vanilla shake

11.04.07

GLACÉAU
smart water®
electrolyte enhanced water

50.7 FLOZ (1QT 1PT 2.7OZ) 1.5L

2 D D D R i n k
M O R E water

11.06.07

117

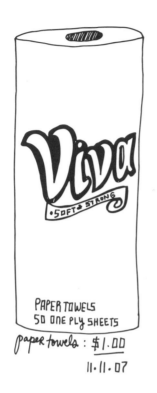

PAPER TOWELS
50 ONE PLY SHEETS

*paper towels: $1.00*
11·11·07

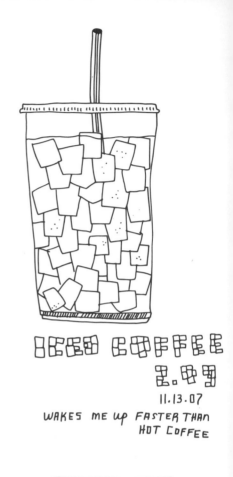

ICED COFFEE
2.09
11.13.07
WAKES ME UP FASTER THAN
HOT COFFEE

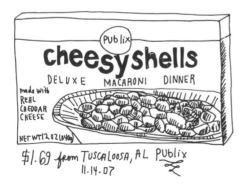

$1.69 from TUSCALOOSA, AL Publix
11.14.07

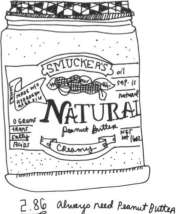

2.86 always need Peanut Butter
in the House.
11.16.07

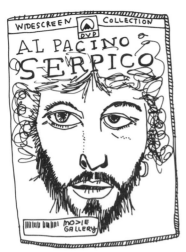

FAVORITE MOVIE OF NOVEMBER.
$1.99 DVD Rental
11.17.07

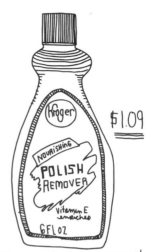

$1.09

I have had the same BLACK NAIL
POLISH on my fingers since Halloween.
11.20.07

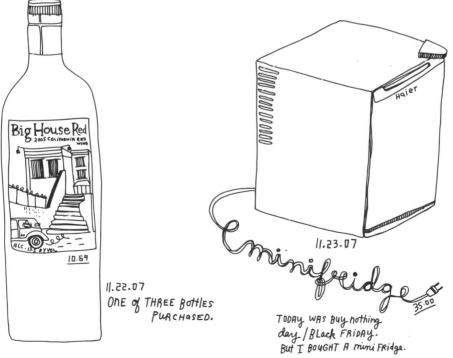

11.22.07
ONE of THREE BOTTLES
PURCHASED.

11.23.07

minifridge
35.00

TODAY WAS BUY nothing
day / BLACK FRIDAY.
BUT I BOUGHT A mini FRIDGE.

119

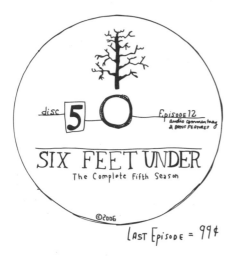

disc **5**

Episode 12
audio commentary
& bonus features

## SIX FEET UNDER
The Complete Fifth Season

©2006

Last Episode = 99¢

I Am DONE. I WATCHED
all SEASONS OVER the past
month or so. I think I am
Going to watch them Again.

11.24.07

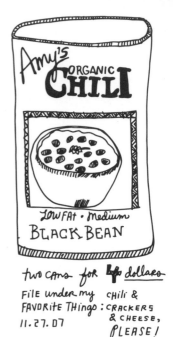

Amy's ORGANIC CHILI

LOW FAT • Medium
BLACK BEAN

two cans for ~~two~~ 4 dollars

FILE under my
FAVORITE THings:
11.27.07

chili &
CRACKERS
& CHEESE,
PLEASE!

ICH Liebe

ETSY.COM
20.00

11.30.07

A DOCUMENTARY FILM
BY GARY HUSTWIT

Plexifilm

Helvetica
Helveti
Helv

"BRilliant"
the Guardian (UK)
"PROVOCATIVE"
new york times
"Blissful"
Chicago Tribune

DVD for MSSTATE AIGA → 20.00
12.01.07

Butter from Kroger: $2.19
12.02.07

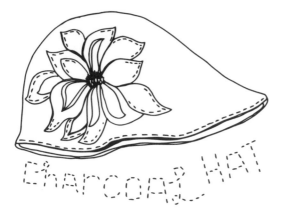

Charcoal Hat

I LEFT THIS ON THE BUS.

12.07.07

45.00

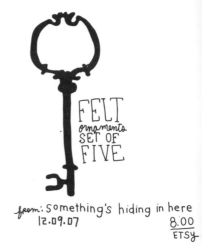

FELT ornaments SET OF FIVE

from: something's hiding in here
12.09.07

8.00
ETSY

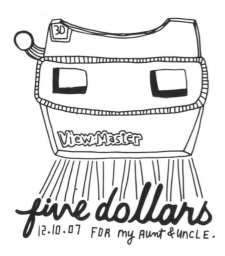

View-Master

*five dollars*
12.10.07 FOR my AUNT & UNCLE.

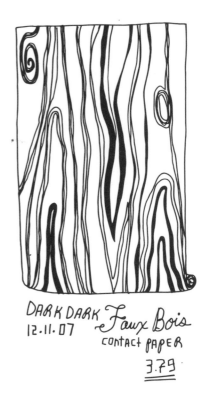

DARK DARK Faux Bois
12.11.07

CONTACT PAPER

3.79

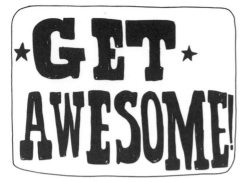

LETTERPRESSED CARDS:
$ 2.00/ RAR RAR PRESS
12.15.07

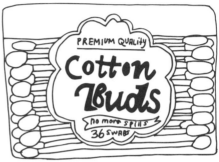

PREMIUM QUALITY
Cotton Buds
no more spills
36 SWABS

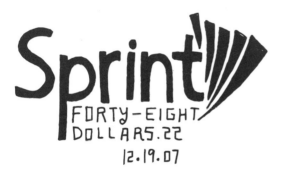

Sprint
FORTY-EIGHT
DOLLARS.22
12.19.07

cotton
eighty-nine
cents
12.17.07

SHIP
PING
TUBE
four dollars.
82 CENTS

12.20.07

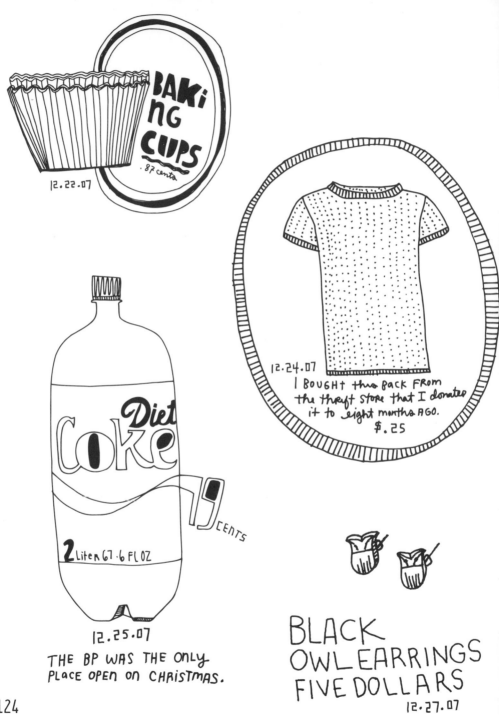

BAKiNG CUPS
.87 cents
12.22.07

12.24.07
I BOUGHT this BACK FROM the theyt store that I donated it to eight months AGO.
$.25

Diet Coke
19 CENTS
2 Liter 67.6 FL OZ

12.25.07
THE BP WAS THE ONLY PLACE OPEN ON CHRISTMAS.

BLACK OWL EARRINGS FIVE DOLLARS
12.27.07

124

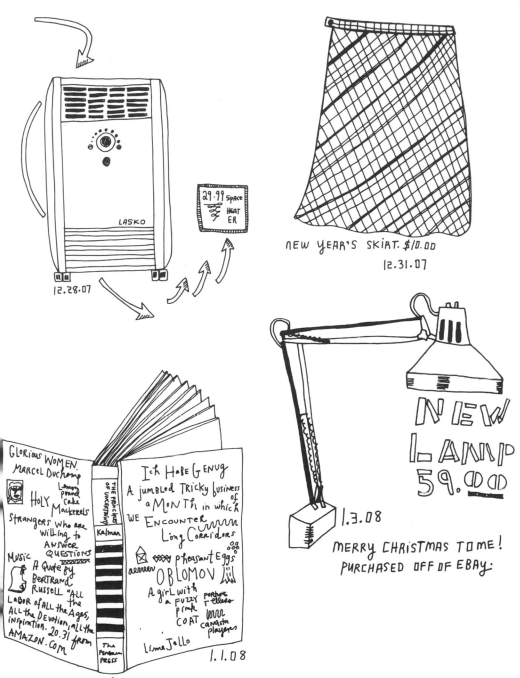

LASKO

29.99 SPACE HEATER

12.28.07

NEW YEAR'S SKIRT. $10.00
12.31.07

GLORIOUS WOMEN.
MARCEL DUCHAMP

HOLY MACKERELS
Lemon pound cake

STRANGERS WHO ARE WILLING TO ANSWER QUESTIONS

MUSIC
A Quote by BERTRAND RUSSELL "ALL the LABOR of ALL the Ages, ALL the Devotion, ALL the inspiration. 20.31 from AMAZON.COM

THE PRINCIPLES OF UNCERTAINTY

Kalman

THE PENGUIN PRESS

Ich Habe Genug
A jumbled Tricky business of a MONTH in which WE ENCOUNTER Long Corridors

Pheasant Eggs
OBLOMOV
A girl with a FUZZY pink COAT
canasta players
Lime Jello

parlous T-cleaco

1.1.08

MAIRA KALMAN'S The Principles of Uncertainty.
I took the dust jacket OFF.

NEW LAMP 59.00
1.3.08
MERRY CHRISTMAS TO ME!
PURCHASED OFF OF EBAY.

125

UP FOR BID: VERY NICE!!
Mossimo WOMEN'S PREMIUM DENIM SKINNY LOW RISE.
SIZE : 8
EXCELLENT CONDITION — LIKE NEW
SMOKE FREE HOME
HAPPY BIDDING !!!
$1.99
$7.00 Shipping
$8.99

ebay

MY FAVORITE PAIR OF JEANS.
This is my 3RD PAIR FROM EBAY.
This WAS DRAWN FROM the PHoto online.
1.4.08

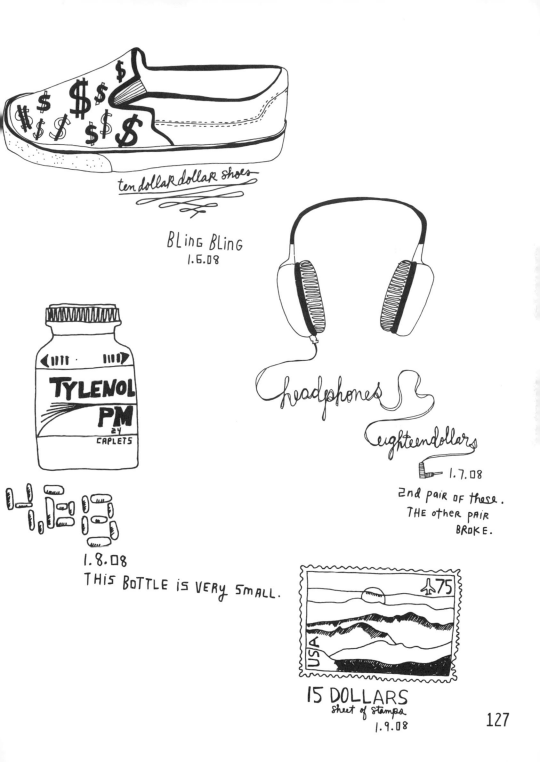

ten dollar dollar shoes

BLing BLing
1.6.08

headphones

eighteendollars
1.7.08

2nd pair of these.
THE other pair
BROKE.

TYLENOL
PM
24
CAPLETS

1.8.08
THIS BOTTLE is VERY SmALL.

USA
75

15 DOLLARS
sheet of stamps
1.9.08

127

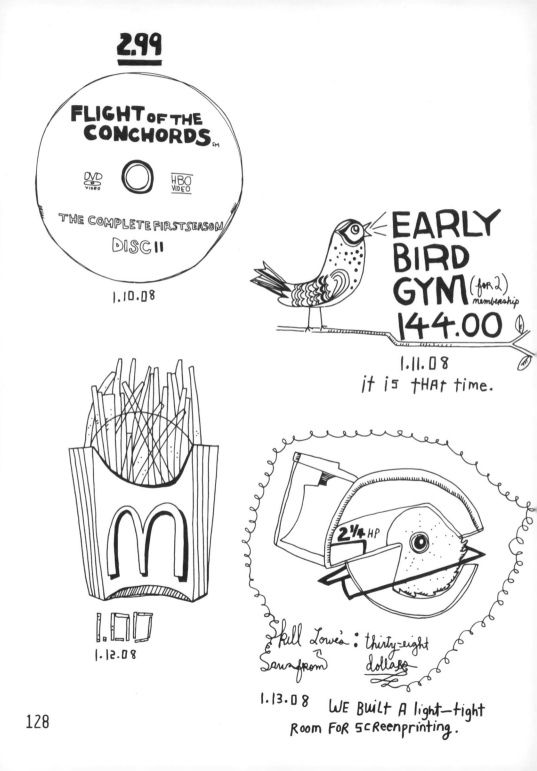

**2.99**

FLIGHT OF THE CONCHORDS sm

DVD VIDEO        HBO VIDEO

THE COMPLETE FIRST SEASON
DISC II

1.10.08

EARLY
BIRD
GYM (for 2) membership
144.00
1.11.08
it is that time.

1.00
1.12.08

2 1/4 HP

Skill Lowe's: thirty-eight
Saws from dollars
1.13.08   WE BUILT A light—tight
Room FOR SCReenprinting.

1.14.08

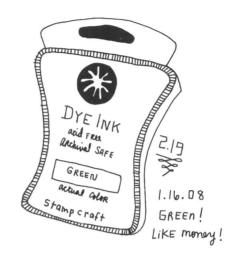

2.19

1.16.08
GREEN!
LiKE money!

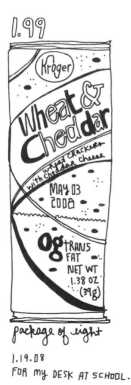

1.19.08
FOR my DESK AT SCHOOL.

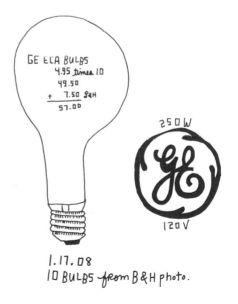

1.17.08
10 BULBS from B & H photo.

129

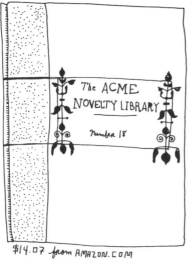

The ACME NOVELTY LIBRARY

number 18

$14.07 from AMAZON.COM

1.18.08

ONE of my FIRST CREDIT-CARD PURCHASES WAS THE FIRST 11 ISSUES OF CHRIS WARE'S ACME NOVELTY LIBRARY in 2000. This is issue 18 & I paid WITH my DEBIT CARD. not CREDIT CARD.

HOLY SHIT I LOVE this SHOW/ SEASON ONE on DVD

Rented → 6.00

1.20.08

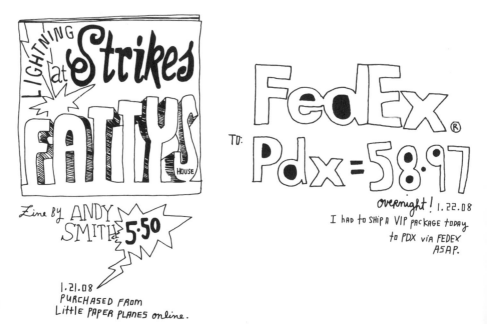

LIGHTNING at Strikes FATTYS HOUSE

Zine BY ANDY SMITH 5.50

1.21.08
PURCHASED FROM
Little PAPER PLANES online.

FedEx®

TO: Pdx = 58.97

overnight! 1.22.08
I had to SHIP A VIP PACKAGE today
to PDX via FEDEX
ASAP.

three 20x 24 frames [FOR SCREEN PRINTING : 14.00 each]

1.23.08

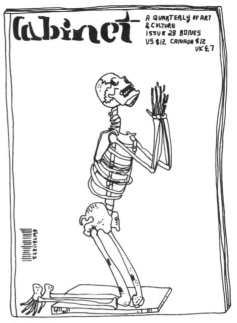

cabinet

A QUARTERLY OF ART & CULTURE
ISSUE 28 BONES
US $12 CANADA $12
UK £7

1.24.08
CABINET SUBSCRIPTION RENEWAL : $20.00

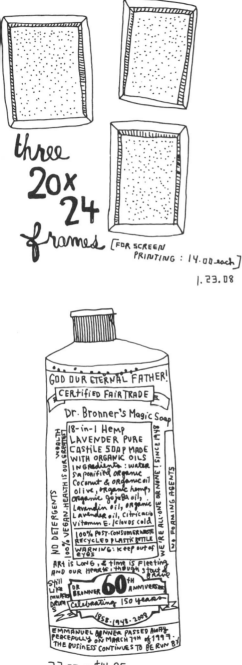

GOD OUR ETERNAL FATHER!
CERTIFIED FAIR TRADE
Dr. Bronner's Magic Soap
18-in-1 Hemp LAVENDER PURE CASTILE SOAP MADE WITH ORGANIC OILS
INGREDIENTS : water, saponified organic coconut & organic oil, olive, organic hemp, organic jojoba oil, Lavandin oil, organic Lavender oil, citric acid, vitamin E. /clouds cold
100% POST-CONSUMER WASTE RECYCLED PLASTIC BOTTLE
WARNING : Keep out of EYES
ART is LONG, & time is fleeting, AND OUR HEARTS, though stout & brave
Still Like muffled DRUMS
DR BRONNER 60th ANNIVERSARY
Celebrating 150 years
1858·1948·2008
EMMANUEL BRONNER PASSED AWAY PEACEFULLY ON MARCH 7th of 1997. THE BUSINESS CONTINUES TO BE RUN BY
(WEALTH) (100% VEGAN. HEALTH IS OUR GREATEST WEALTH : SINCE 1948) (NO DETERGENTS) (WE ARE ALL-ONE OR NONE) (NO FOAMING AGENTS)

32 OZ = $14.95
LAVENDER HEMP / PURCHASED AT WALGREENS.
1.25.08

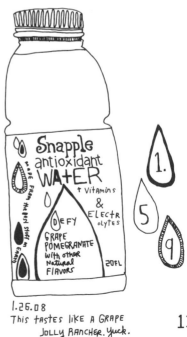

Snapple antioxidant WATER
+ vitamins & ELECTRolytes
DEFY
GRAPE POMEGRANATE with other natural FLAVORS
MADE FROM the best stuff on earth
20 FL

1. 5 9

1.26.08
This tastes like A GRAPE JOLLY RANCHER. Yuck.

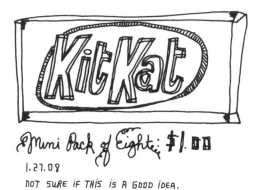

Mini Pack of Eighteen: $1.00

1.27.08

NOT SURE IF THIS IS A GOOD IDEA.

BARNES & NOBLE

COFFEE/ROOM FOR CREAM: 2.09
1.30.08 I AM SO NOT into the MORNING BARISTA.

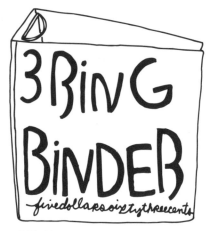

3 RING BINDER

fivedollarssixtythreecents

1.31.08
FOR MY SCHOOL'S DEPARTMENT REVIEW.

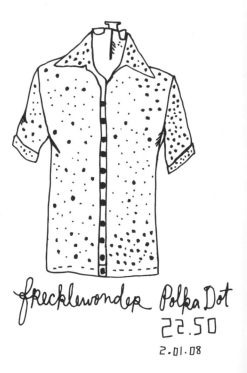

frecklewonder PolkaDot

22.50

2.01.08

**TARGET**

Statement closing Date: JULY 23, 200[

TARGET VISA CREDIT Account Summary
Total Credit Limit          $0
CASH Limit                  $0
Available CREDIT            $0
Portion Available FOR CASH  $0

QUESTIONS? Call us!    1 888.755 5856
Target Credit Services 1·800 347·5842
TDD/TDY              11 612·307·8622
OUTSIDE the U S.

| | |
|---|---|
| PREVIOUS Balance | $976 44 |
| PAyments & Credits | −25.00 |
| Purchases & Advances | 0.00 |
| Other Charges | 0.00 |
| FINANCE CHARGES | 10.35 |
| NEW BALANCE | $961 79 |
| Minimum Payment DUE | $25 00 |
| PAYMENT DUE DATE | August 17, 200[ |

---

IMPORTANT MESSAGES

FOR Your Information
Your next automatic payment will be on 8-17-2008 for $25 00. Payments & other credits made
between Your statement date & payment due date may affect Your Automatic Payment amount. A[
no time will your Automatic Payment Result in a Credit Balance to your account.

PAYMENT & CRedits
JULY 18 Auto Payment                    − $25 00

                    TOTAL PAYments   − $25.00
                    & CRedits

---

**TARGET**

TARGET NATIONAL BANK
P.O. BOX 59317
Minneapolis, MN 55459-0317

KATE BINGAMAN
PORTLAND, OR 97214

NEW BALANCE ·        $961.79
Minimum Payment
          DUE ·      $ 25.00
Payment DUE DATE ·   August 17th,

AMOUNT
ENCLOSED    $          .

Payment Will Be AUTO PAID

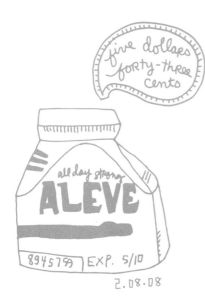

five dollars
forty-three
cents

all day strong
ALEVE

8945799   EXP. 5/10

2.08.08

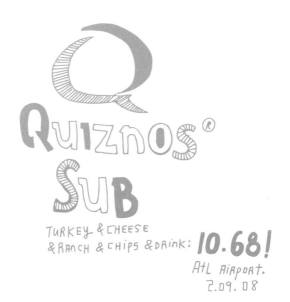

Quiznos® Sub

TURKEY & CHEESE
& RANCH & CHIPS & DRINK: **10.68!**

AtL AIRPORT.
2.09.08

6.99

green works
natural
glass &
surface cleaner

comm-
ercial

READY to
USE

CLOROX

2.10.08

eye shadow

SHADOW
BRUSH
2.99

my Luggage was lost FOR
a FEW DAYs. BOUGHT
SOME NEW MAKEUP STUFF.
2.12.08

137

PUBLIC DESIGN CENTER

GOOD FOR 1 CLINIC

550 WOODEN NICKELS FOR
THE PUBLIC DESIGN CENTER = 70.00
2.13.08

AVEDA

·AVEDA·
The ART & SCIENCE
OF PURE FLOWER &
PLANT ESSENCES

shampure™

SHAMPOO
SHAMPOOING

ABOVE & BEYOND
SHAMPOO with
morikue™

8.5 fl oz/oz liq/250

nine DOLLARS
69 ¢ENTS  PORTLAND, MAINE
FRIENDS IAN & KARI
HAD this in their SH
WHEN I STAYED WITH
this MONTH. I LOVED
2.16.08

PLASTIC FORKS
$1.49
FORKS for BBQ!
2.19.08

Girl Scouts
cookie time
12.00     THIN MINTS
          SHORT BREAD
2.20.08   CARAMEL DELIGHTS
          PEANUT BUTTER PATTIES
          HELL, YES

138

# WHATDIDYOUBUYTODAY.COM

BLOG DOMAIN REDIRECT NAME

15 DOLLARS ———> MEDIA TEMPLE
2.21.08

Crest

.50

2.24.08

I FORGOT MY
TOOTHPASTE.
THIS WAS PURCHASED
AT THE HOTEL.

IT WAS
MINI & 50¢.

The ORIGINAL Celebrated
CURIOUSLY STRONG®
PEPPERMINTS

CALLARD
& BOWSER

ALTOIDS

NET. WT 1.76 OZ (50g)

2.25.08

TWO BUCKS!
FIFTY cents

THE
HOODED
DEER

2.26.08

three buttons
for $1.00

139

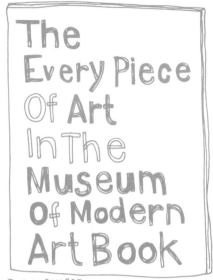

The
Every Piece
Of Art
In The
Museum
Of Modern
Art Book

TWENTY DOLLARS
ARTIST Jason Polan
DREW EVERY PIECE in the MOMA.
2.27.08

pull & seal   pull & seal   pull & seal   pull & seal   pull & seal

50 ENVELOPES
4.95

2.29.08
FOR ZINE ORDERS!

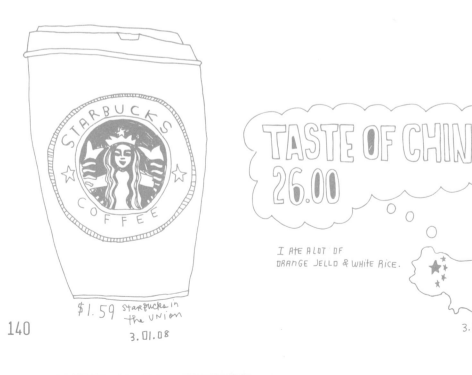

STARBUCKS COFFEE

$1.59   STARBUCKS in
the UNION
3.01.08

TASTE OF CHINA
26.00

I ATE A LOT OF
ORANGE JELLO & WHITE RICE.

3.02.08

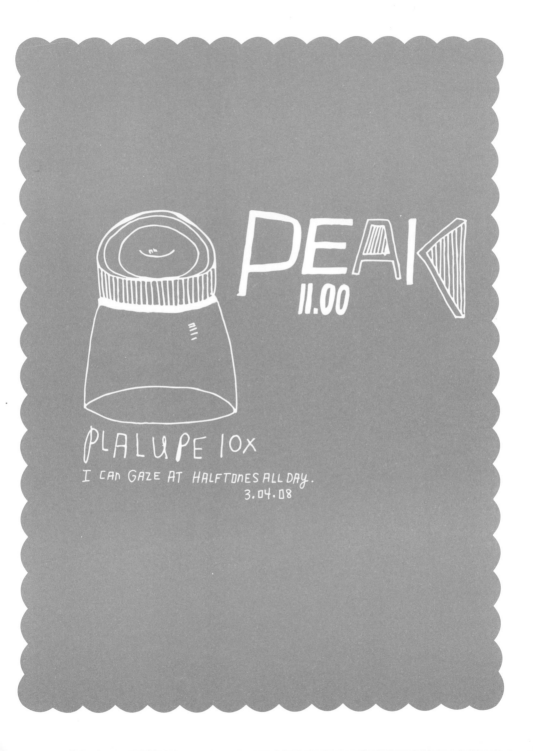

ALIAS

SEASON ONE on DVD = $6.00
3.05.08

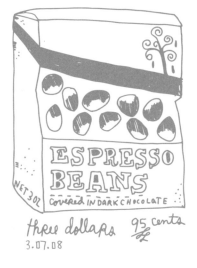

ESPRESSO BEANS

COVERED IN DARK CHOCOLATE

NET 3 OZ

three dollars 95 cents
3.07.08

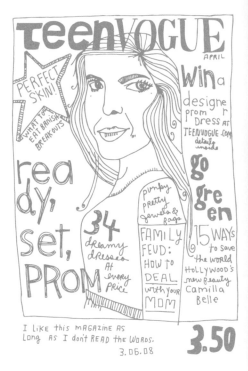

teenVOGUE

APRIL

PERFECT SKIN!

WHAT TO EAT BANISH BREAKOUTS

WIN a designer prom Dress AT TEENVOGUE.com details inside

rea dy, set, PROM

go gre en

punky pretty jewels & bags

34 dreamy dresses At every price

FAMILY FEUD: HOW TO DEAL WITH YOUR MOM

15 WAYS to save the world HOLLYWOOD's new Beauty Camilla Belle

I LIKE this MAGAZINE AS Long AS I don't READ the WORDS.
3.06.08

3.50

ORBITZ

A STEP AHEAD

FROM TVP → RIC

three hundred sixty-eight dollars. 99/100
3.08.08

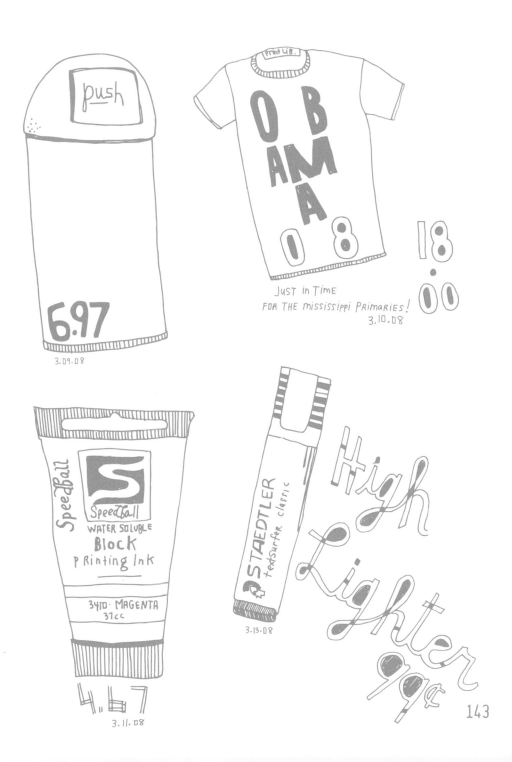

push

6.97

3.09.08

Print LIB.

O B
A M
A

0 8

JUST in TIME
FOR THE mississippi Primaries!
3.10.08

18
.00

Speedball

Speedball
WATER SOLUBLE
Block
PRinting Ink

3410 · MAGENTA
37cc

4.67

3.11.08

STAEDTLER textsurfer classic

3.13.08

High
Lighter
99¢

143

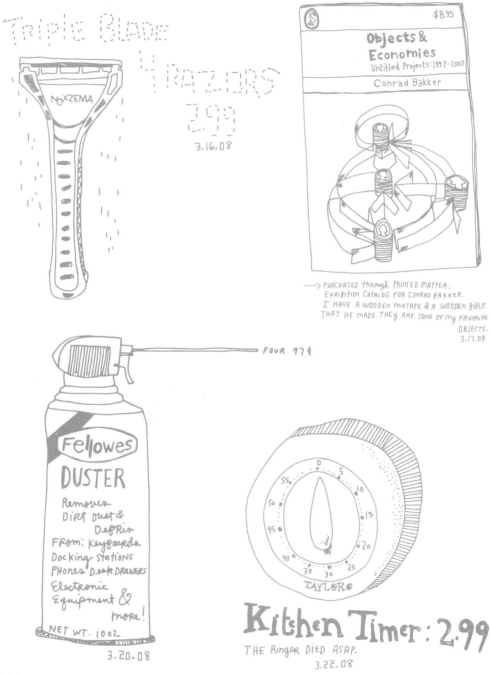

Triple Blade

4 Razors
3.99
3.16.08

$8.95

Objects &
Economies
Untitled Projects: 1997-2007

Conrad Bakker

→ PURCHASED through PRINTED MATTER.
EXHIBITION CATALOG FOR CONRAD BAKKER.
I HAVE A WOODEN MIXTAPE & A WOODEN BIBLE
THAT HE MADE. THEY ARE SOME OF MY FAVORITE
OBJECTS.
3.17.08

FOUR 97¢

Fellowes
DUSTER
Removes
DIRT DUST &
DEBRIS
FROM: KeyBoards
Docking Stations
PHONES DESK DRAWERS
Electronic
Equipment &
more!
NET WT. 10 OZ
3.20.08

TAYLOR®

Kitchen Timer: 2.99
THE RINGER DIED ASAP.
3.22.08

144

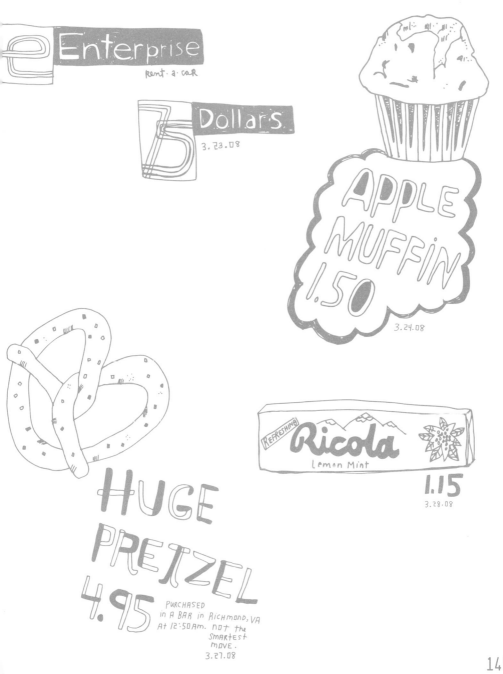

Enterprise
rent·a·car

Dollars
3.23.08

APPLE MUFFIN 1.50
3.24.08

Ricola
REFRESHING
Lemon Mint

1.15
3.28.08

HUGE PRETZEL 4.95
PURCHASED
IN A BAR IN RICHMOND, VA
AT 12:50 AM. NOT the
SMARTEST
MOVE.
3.27.08

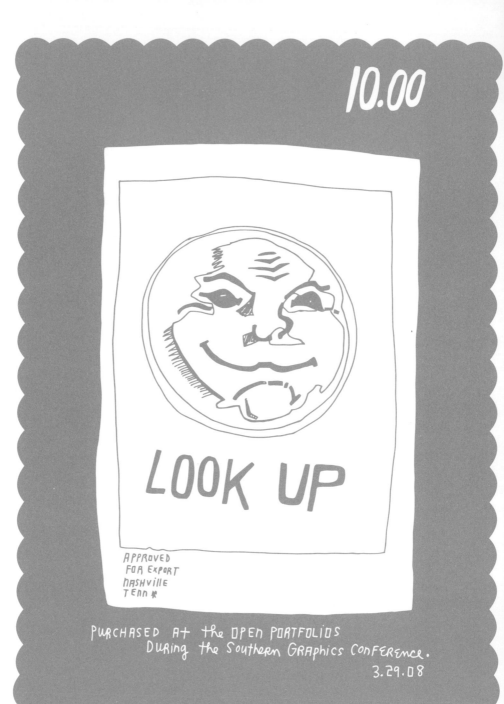

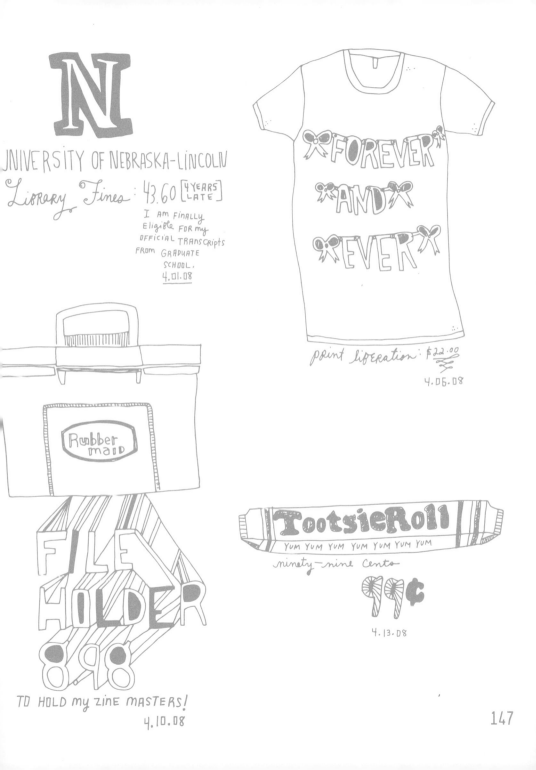

UNIVERSITY OF NEBRASKA-LINCOLN

Library Fines : 43.60 [4 YEARS LATE]

I AM FINALLY Eligible FOR my OFFICIAL TRANSCRIPTS FROM GRADUATE SCHOOL.
4.01.08

FOREVER AND EVER

print liberation : $22.00
4.06.08

Rubber maid

FILE HOLDER 8.98

TO HOLD my ZINE MASTERS!
4.10.08

TootsieRoll

YUM YUM YUM YUM YUM YUM YUM

ninety-nine cents

99¢

4.13.08

147

TurboTax 7770

4.14.08

UNITED STATES
POSTAL SERVICE
SIX DOLLARS 40¢

4.16.08

THIS HAS TURNED into my UNIFORM
50% OFF TOO!
4.15.08

THE NEW PORNOGRAPH
ERS
with OKKERVIL
RIVER
the Georgia Theatre
THURSDAY APRIL 17, 2008
DOORS open @ 9:00 PM

0084 87

$22.00 ADVANCE
$25.00 DAY OF SHOW

4.17.08

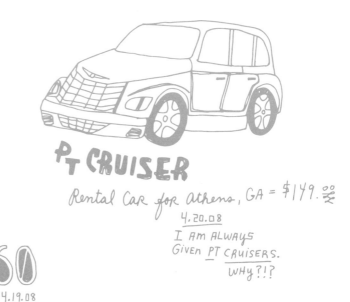

**PT CRUISER**

Rental Car for Athens, GA = $149.⁰⁰

4.20.08

I AM ALWAYS
GIVEN PT CRUISERS.
WHY?!?

Robinson & Son Shell
14 COMMERCE PLACE
Tallapoosa, Georgia

**$26.60**

4.19.08

**Seventy-nine
Short Essays on Design**
Michael Bierut

**79**

used from amazon.com
**$10.97**
4.22.08

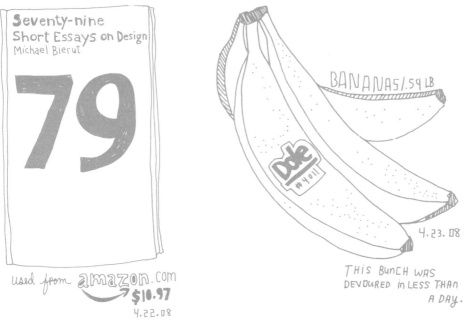

BANANAS 1.59 LB

Dole
# 4011

4.23.08

THIS BUNCH WAS
DEVOURED IN LESS THAN
A DAY.

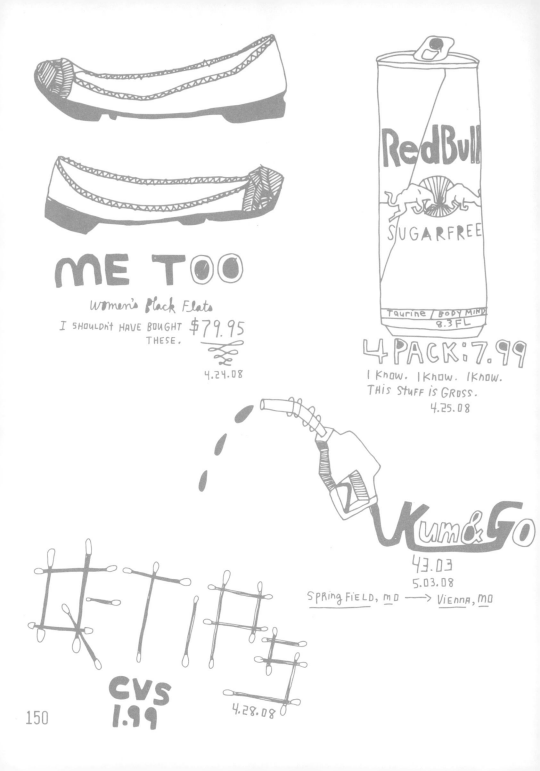

ME TOO

Women's Black Flats
I SHOULDN'T HAVE BOUGHT
THESE.
$79.95

4.24.08

RedBull
SUGARFREE
Taurine / BODY MIND
8.3 FL

4 PACK: 7.99
I KNOW. I KNOW. I KNOW.
THIS STUFF IS GROSS.
4.25.08

Kum&Go
43.03
5.03.08
SPRING FIELD, MO ⟶ VIENNA, MO

CVS
1.99
4.28.08

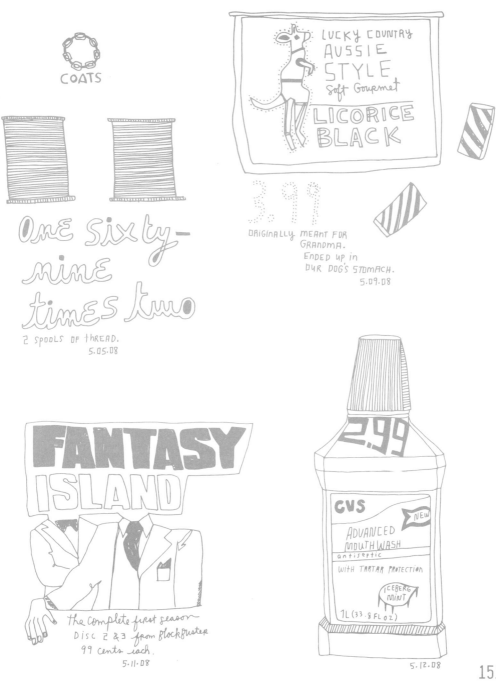

COATS

One sixty-
nine
times two

2 spools of thread.
5.05.08

LUCKY COUNTRY
AUSSIE
STYLE
soft Gourmet
LICORICE
BLACK

3.99

ORIGINALLY MEANT FOR
GRANDMA.
ENDED UP IN
OUR DOG'S STOMACH.
5.09.08

FANTASY
ISLAND

the complete first season
DISC 2 & 3 from Blockbuster
99 cents each.
5.11.08

2.99

CVS
NEW
ADVANCED
MOUTHWASH
antiseptic
WITH TARTAR PROTECTION
ICEBERG
MINT
1L (33.8 FL OZ)

5.12.08

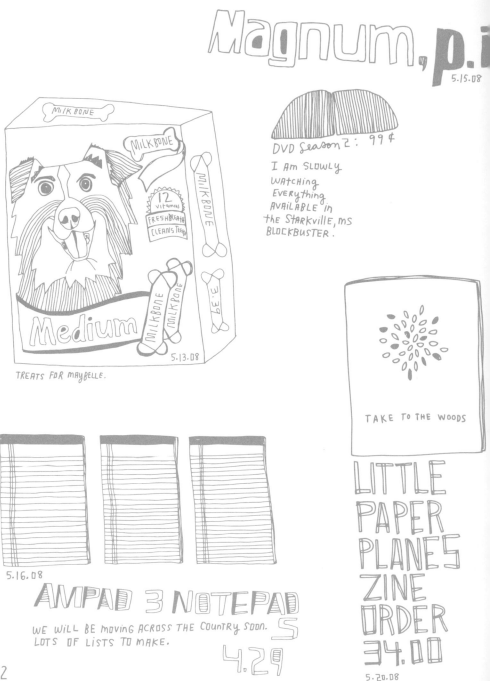

Magnum, p.i
5.15.08

DVD Season 2 : 99¢
I AM SLOWLY
WATCHING
EVERYTHING
AVAILABLE IN
THE STARKVILLE, MS
BLOCKBUSTER.

MILKBONE
MILKBONE
MILKBONE
MILKBONE
12 vitamins
FRESH BREATH
CLEANS TEETH
MILKBONE
MILKBONE
3.39
Medium
5.13.08

TREATS FOR MAYBELLE.

TAKE TO THE WOODS

5.16.08
AMPAD 3 NOTEPADS

WE WILL BE MOVING ACROSS THE COUNTRY SOON.
LOTS OF LISTS TO MAKE.

4.29

LITTLE
PAPER
PLANES
ZINE
ORDER
34.00

5.20.08

152

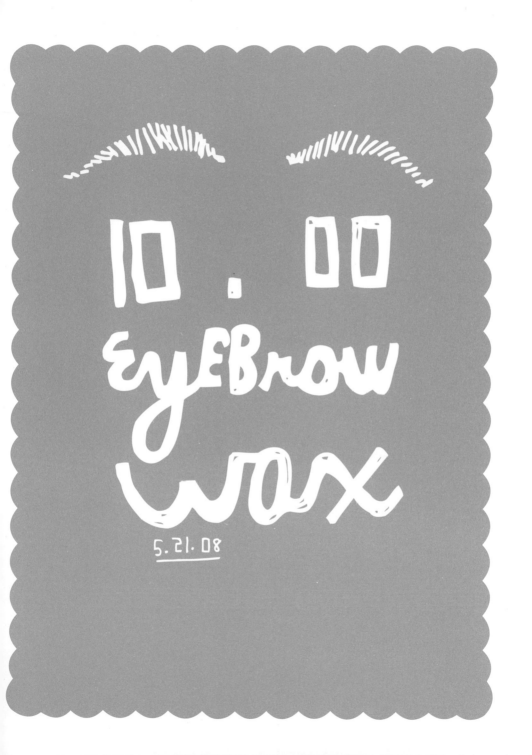

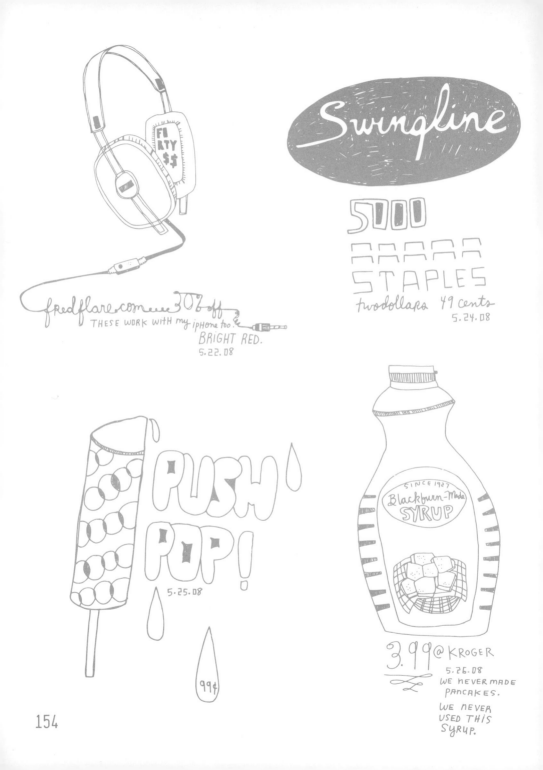

fredflare.com 30% off
THESE WORK WITH my iphone too.
BRIGHT RED.
5.22.08

Swingline
5000
STAPLES
two dollars 49 cents
5.24.08

PUSH!
POP!
5.25.08
99¢

SINCE 1927
Blackburn-Made
SYRUP

3.99 @ KROGER
5.26.08
WE NEVER MADE
PANCAKES.

WE NEVER
USED THIS
SYRUP.

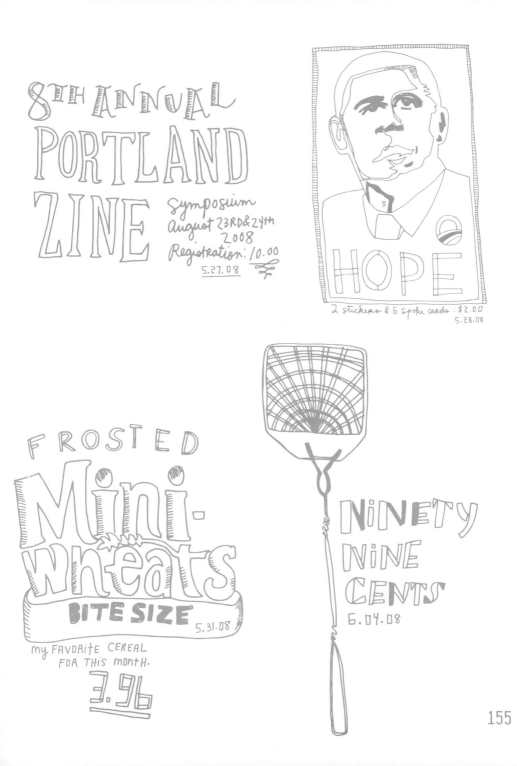

8TH ANNUAL
PORTLAND
ZINE
Symposium
August 23RD & 24th
2008
Registration: 10.00
5.27.08

HOPE

2 stickers & 5 spoke cards : $2.00
5.28.08

FROSTED
Mini-
Wheats
BITE SIZE
5.31.08

my FAVORITE CEREAL
FOR THIS MONTH.
3.96

NINETY
NINE
CENTS
6.04.08

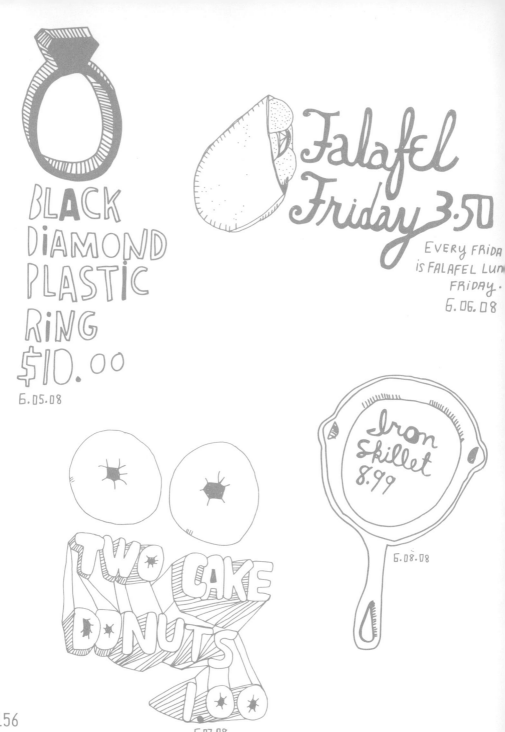

BLACK
DIAMOND
PLASTIC
RING
$10.00

6.05.08

Falafel
Friday 3.50

EVERY FRIDA
IS FALAFEL Lun
FRIDAY.
6.06.08

Iron
Skillet
8.99

6.08.08

TWO CAKE
DONUTS
1.00

6.07.08

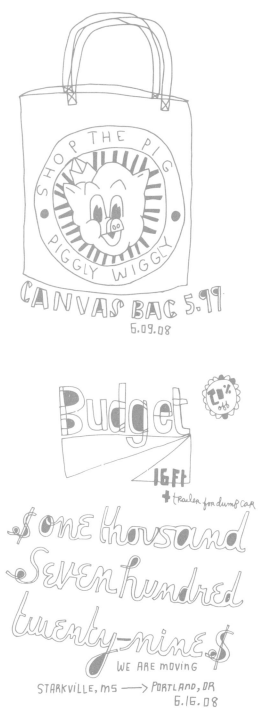

SHOP THE PIG
PIGGLY WIGGLY
CANVAS BAG 5.99
6.09.08

Budget
60% off
16 Ft
+ trailer for dump car

$ ONE thousand
Seven hundred
twenty-nine. $
WE ARE MOVING
STARKVILLE, MS ⟶ PORTLAND, OR
6.16.08

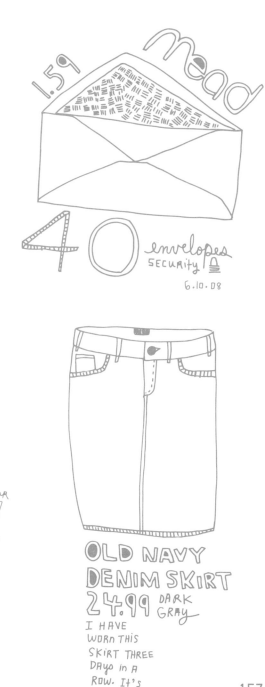

1.59
mead
40 envelopes
SECURITY
6.10.08

OLD NAVY
DENIM SKIRT
24.99 DARK
GRAY
I HAVE
WORN THIS
SKIRT THREE
DAYS IN A
ROW. IT'S
GOT STRETCH!
6.18.08

157

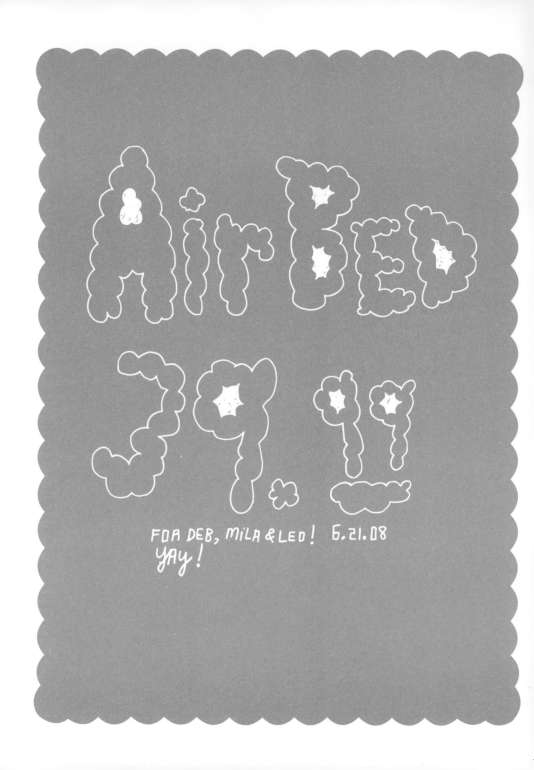

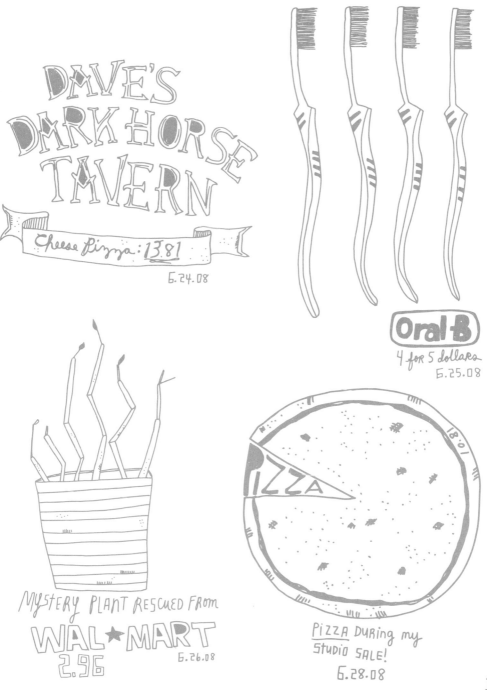

DAVE'S DARK HORSE TAVERN

Cheese Pizza : 13.81

6.24.08

Oral-B

4 for 5 dollars

6.25.08

MYSTERY PLANT RESCUED FROM

WAL★MART
2.96

6.26.08

PIZZA

PIZZA DURING MY
STUDIO SALE!

6.28.08

159

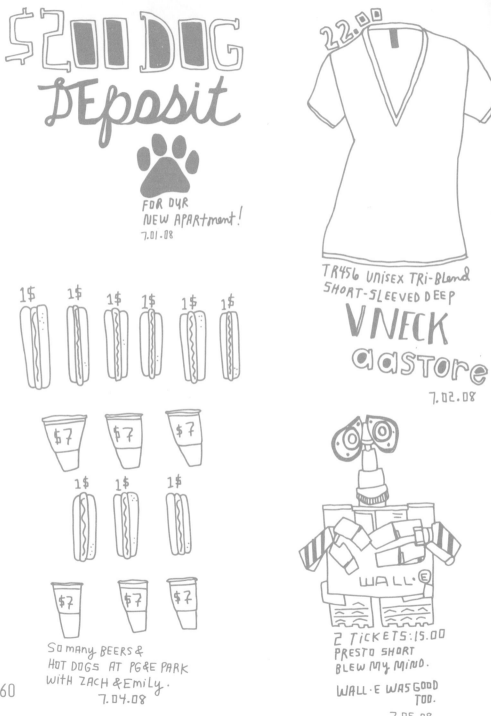

$200 DOG DEPOSIT

FOR OUR
NEW APARTMENT!
7.01.08

1$ 1$ 1$ 1$ 1$ 1$

$7 $7 $7

1$ 1$ 1$

$7 $7 $7

SO many BEERS &
HOT DOGS AT PG&E PARK
WITH ZACH & Emily.
7.04.08

22.00

TR456 UNISEX TRI-Blend
SHORT-SLEEVED DEEP
VNECK
aastore
7.02.08

WALL·E

2 TICKETS: 15.00
PRESTO SHORT
BLEW MY MIND.

WALL·E WAS GOOD
TOO.
7.05.08

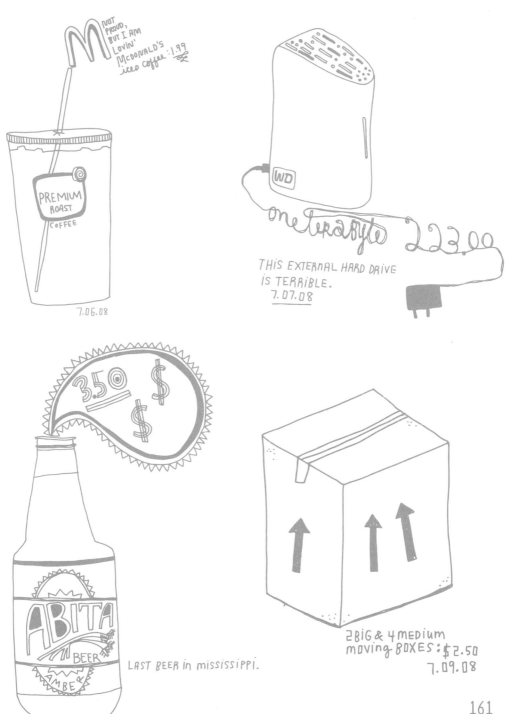

NOT PROUD, BUT I AM LOVIN' McDONALD'S iced coffee : 1.99

PREMIUM ROAST COFFEE

7.06.08

one terabyte 223.00

THIS EXTERNAL HARD DRIVE IS TERRIBLE.
7.07.08

3.50 $ $ $

ABITA BEER AMBER

LAST BEER in mississippi.

7.08.08

2 BIG & 4 MEDIUM moving BOXES : $2.50
7.09.08

161

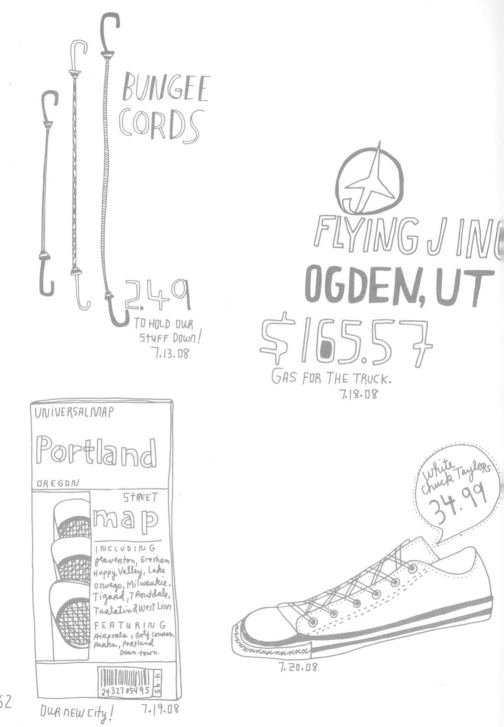

BUNGEE CORDS

2.49
TO HOLD OUR
STUFF DOWN!
7.13.08

FLYING J INC
OGDEN, UT
$165.57
GAS FOR THE TRUCK.
7.18.08

UNIVERSAL MAP

Portland
OREGON
STREET
map
INCLUDING
Beaverton, Gresham
Happy Valley, Lake
Oswego, Milwaukie,
Tigard, Troutdale,
Tualatin & West Linn

FEATURING
Airports, Golf courses,
parks, Portland
Down town.

2432705495

162

OUR NEW CITY!    7.19.08

White Chuck Taylors
34.99

7.20.08

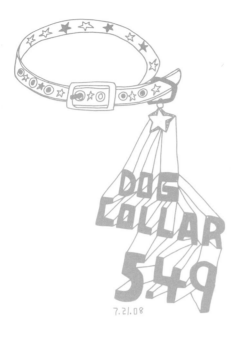

DOG COLLAR 5.49

7.21.08

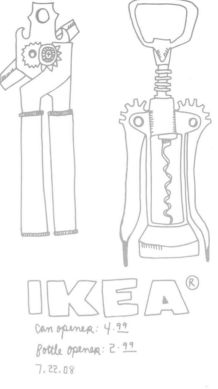

IKEA®

Can opener: 4.99
Bottle opener: 2.99

7.22.08

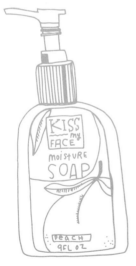

KISS my FACE
MOISTURE SOAP

PEACH
9FL OZ

3.99

7.24.08

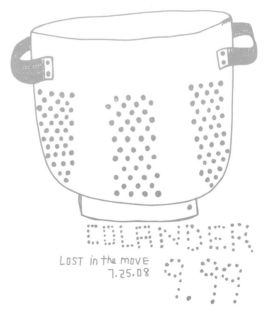

COLANDER

LOST in the move
7.25.08

9.99

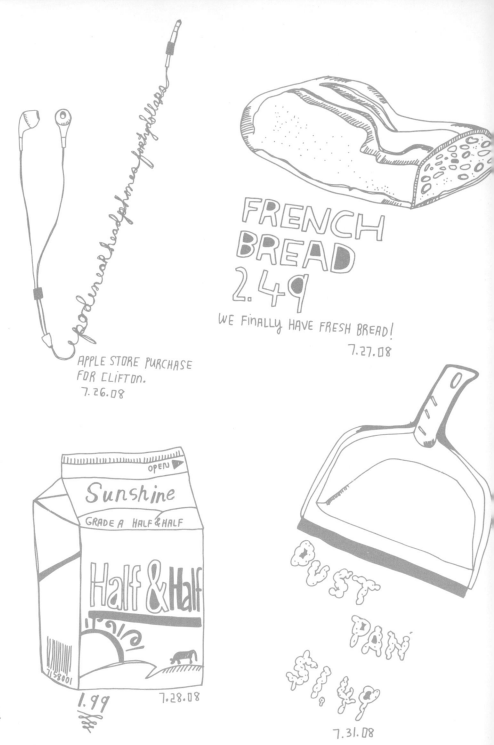

ipodearheadphonesforthelaptop

APPLE STORE PURCHASE
FOR CLIFTON.
7.26.08

FRENCH
BREAD
2.49
WE FINALLY HAVE FRESH BREAD!
7.27.08

Sunshine
OPEN ▶
GRADE A  HALF & HALF
Half & Half
7158001
1.99
7.28.08

DUST
PAN
$1.49
7.31.08

164

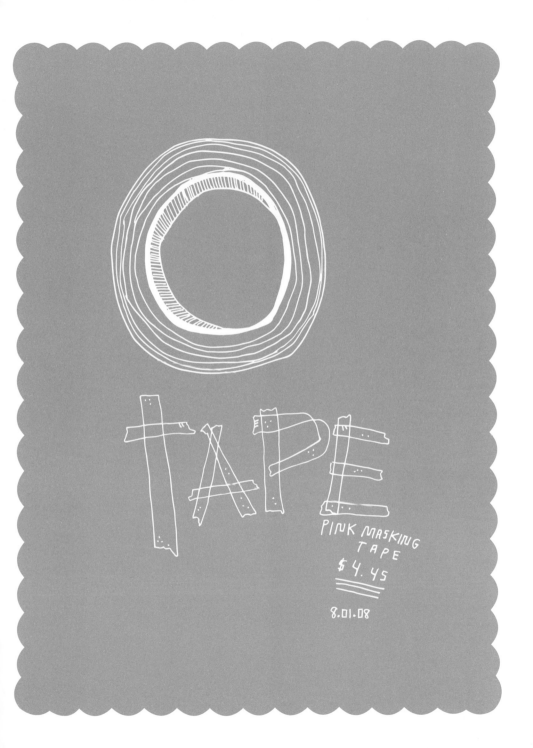

# FROM A
# TOASTER
# OVEN
## TO
# SUPERFINE
# PENS

USAA Savings Bank
PO Box 14050
Las Vegas, NV 89114-4050

USAA

KATE BINGAMAN

PORTLAND, OR 97214·1847

‖₁‖₁₁‖₁‖₁‖₁₁‖₁₁₁₁‖₁₁₁₁‖₁₁₁₁₁₁₁₁₁₁

USAA CREDIT CARD SERVICES
10750 MCDERMOTT FWY
San Antonio, TX 78288-0570

**CREDIT CARD ACCOUNT SUMMARY**

| | |
|---|---|
| NEW BALANCE | $5,522.62 |
| Minimum Payment DUE | $92.00 |
| Payment DUE DATE | 01/24/09 |

| amount Enclosed | $ |
|---|---|

TO ENSURE PROPER CREDIT, please return this portion with your Check or Money order payment made payable to USSA Savings BANK  DO NOT SEND CASH.

ADDRESS

CITY          STATE          ZIP
(   )
HOME PHONE

BUSINESS PHONE

000 823 642 000        0002 1232 8 12 1977 3212

USAA
SAVINGS
BANK

USAA

MasterCard

CREDIT Limit          $10,500.00
AVAILABLE CREDIT      $4,977.00

Questions? Call Customer Service
LOST OR Stolen cards?

OR WRITE us at:
PO BOX 65020, SAN ANTONIO, TX 78265·5020

| | |
|---|---|
| STATEMENT CLOSING DATE | 12/30 |
| PRevious Balance | $5,581. |
| Payments | $95. |
| PURCHASES & Debits | 0.0 |
| TOTAL FINANCE CHARGES | 36. |
| Minimum Payment DUE | $92- |
| Payment DUE Date | 01/24/0 |

TRANSACTIONS

| Trans | POST | CARD | REF number | Description | Amou |
|---|---|---|---|---|---|
| 12/30 | 12/30 | | * FINANCE CHARGE * | | 36.57 |
| 12/23 | 12/23 | M | 4218008 2114 | USAA.COM PAyment-THanks San Antonio | -95. |

FINANCE CHARGE

| | AVERAGE DAILY BALANCE | monthly PERIODIC RATE | nominal Annual %Rate | PERIOD Finan CHAR |
|---|---|---|---|---|
| PURCHASE | $3,652.07 | .658% | V 7.90% | $24. |
| CASH Advance | $1,905.23 | .658% | V 7.90% | 12 |
| PROMOTIONAL Cash Advance | $0.00 | .658% | 7.90% | 0. |

Days in Billing Period      32
ANNUAL PERCENTAGE RATE  7.90%

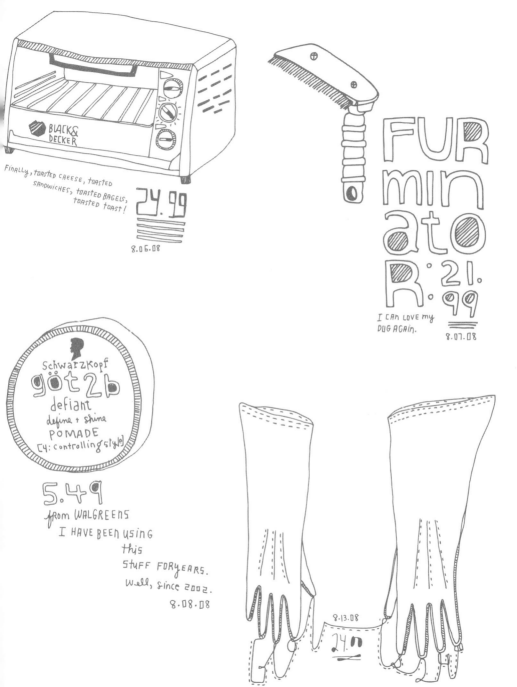

BLACK & DECKER

FINALLY, TOASTED CHEESE, TOASTED SANDWICHES, TOASTED BAGELS, TOASTED TOAST!

24.99

8.06.08

FUR min ato R. 21. 99

I CAN LOVE MY DOG AGAIN.

8.07.08

Schwarzkopf göt2b defiant define + shine POMADE [4: controlling style]

5.49

from WALGREENS I HAVE BEEN USING this STUFF FOR YEARS. Well, since 2002.

8.08.08

8.13.08

24.n

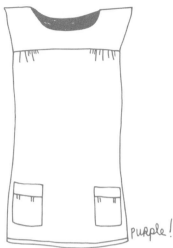

RSATR302
SLEEVELESS-TRI-BLEND
PLEATED POCKET DRESS

purple!

American
Apparel

$38.00
8.17.08

# MOSCOW MULE

ONE PART VODKA
ONE PART LIME JUICE
3 PARTS GINGER BEER
DASH ACVGOSTURA BITTERS

6.50 @ THE SECRET
SOCIETY
116 NE
RUSSELL STREET
8.18.08

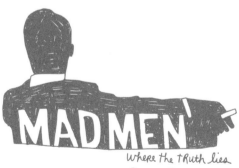

MADMEN

where the truth lies
Season 2
Season PASS

22.00
8.19.08 itunes

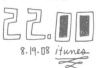

2 CHEESEBURGERS
1 REGULAR FRY
1 3 PIECE ONION RINGS

11 DOLLARS    83 CENTS

8.21.08

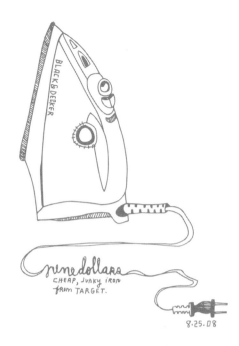

**CITY OF PORTLAND**
Title No. 16 ORD. 165189
Circuit Court for Multnomah
County

## PARKING VIOLATION

Citation# HA08925691

| DATE | TIME | TIME ISSUED |
|------|------|-------------|
| 8/22/2008 | | 02:36 PM |
| LICENSE# | | STATE |
| KTED83 | | MS |
| MAKE | METER# | LIMIT | V/S |
| TOYOTA | | | |
| RECEIPT | EXP TIME | BEAT# |
| | | 41 |
| | LOCATION | |

SE 27TH AVE
Between ASH ST & ANKENY St

| SIDE | OFFICER | OFC |
|------|---------|-----|
| E | D. BARKLEY | 49 |

VIOLATION: BLOCKED DRIVEWAY
Amount DUE: $60.00
Comments: TOW

8.22.08  WE WERE TOWED!
I could have sworn
that it was a REAL
PARKING Space.

BLACK & DECKER

nine dollars
CHEAP, JUNKY IRON
from TARGET.
8.25.08

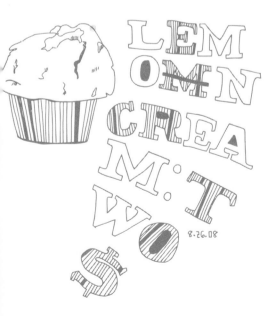

LEMON
~~O~~MN
CREA
M. T
WO
$
8.26.08

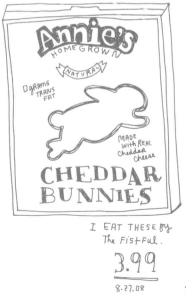

**Annie's**
HOMEGROWN
NATURAL
0 GRAMS
TRANS
FAT
MADE
WITH REAL
Cheddar
Cheese.
**CHEDDAR
BUNNIES**

I EAT THESE BY
The Fistful.

**3.99**
8.27.08

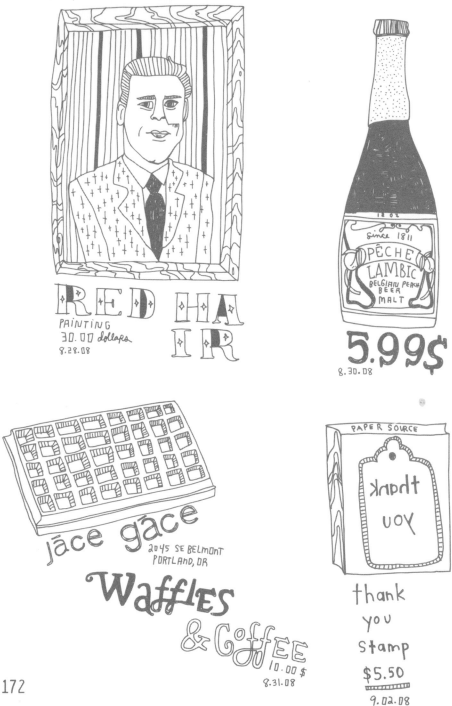

RED HAIR
PAINTING
30.00 dollars
8.28.08

since 1811
PÊCHE
LAMBIC
BELGIAN PEACH
BEER
MALT

5.99$
8.30.08

jāce gáce
2045 SE BELMONT
PORTLAND, OR
Waffles
& Coffee
10.00 $
8.31.08

PAPER SOURCE
thank
you
thank
you
stamp
$5.50
9.02.08

172

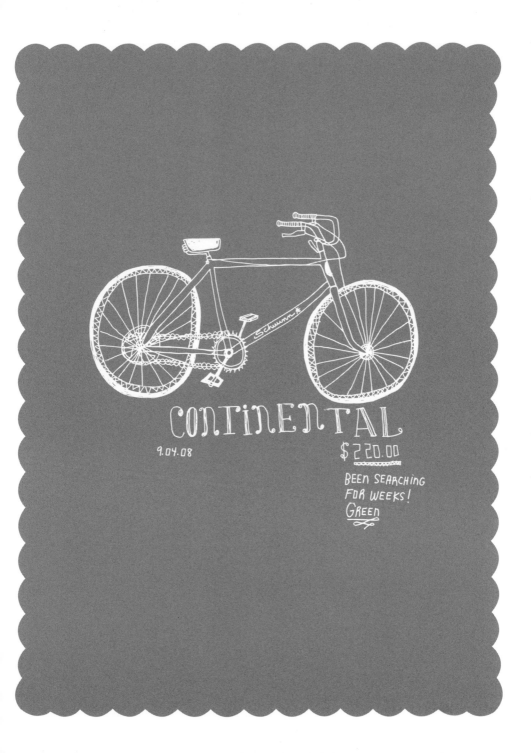

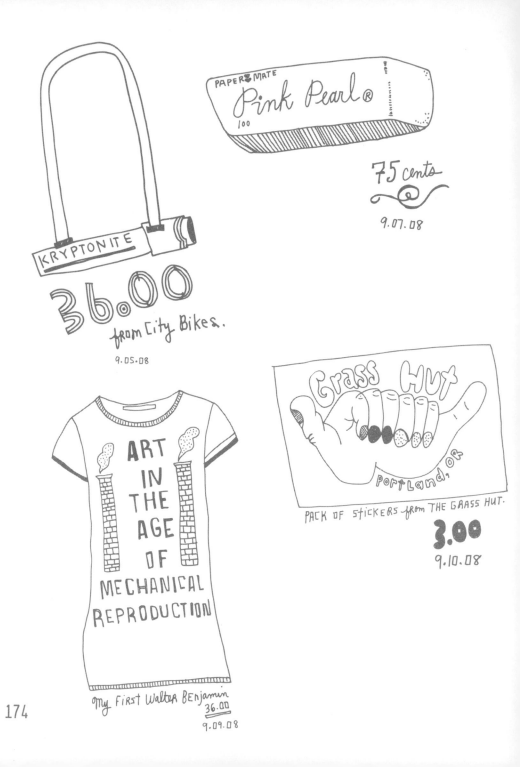

KRYPTONITE

36.00

from City Bikes.

9.05.08

PAPER☘MATE
Pink Pearl ®
100

75 cents

9.07.08

ART
IN
THE
AGE
OF
MECHANICAL
REPRODUCTION

My First Walter Benjamin
36.00
9.09.08

Grass Hut

PORTLAND, OR

PACK OF STICKERS from THE GRASS HUT.

3.00

9.10.08

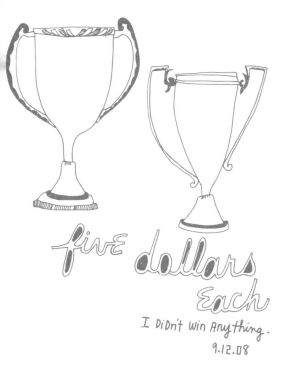

*five dollars Each*

I Didn't win Anything.
9.12.08

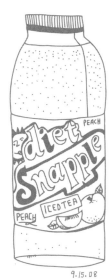

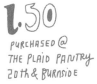

1.50

purchased @
THE PLAID PANTRY
20th & BURNSIDE

9.15.08

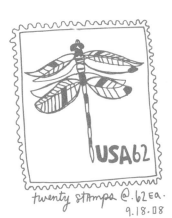

USA 62

twenty stamps @ .62 ea.
9.18.08

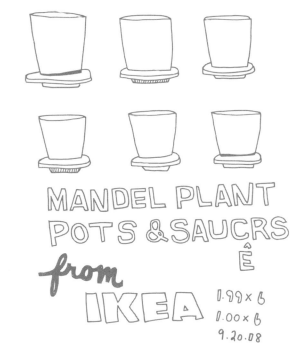

MANDEL PLANT
POTS & SAUCRS
Ẽ
*from*
IKEA

1.99 × 6
1.00 × 6
9.20.08

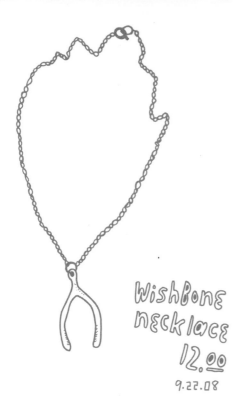

Wishbone
necklace
12.00

9.22.08

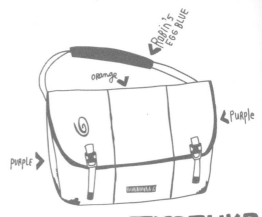

Robin's EGG BLUE

orange ✓

purple ➤

◀ purple

TIMBUK2

extra Large BAG: USED
40.00

9.23.08

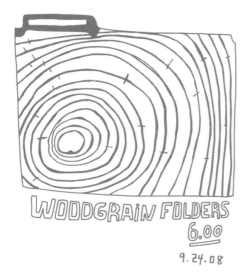

WOODGRAIN FOLDERS
6.00

9.24.08

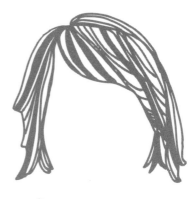

HAircut
and
Color: 90 $

9.25.08

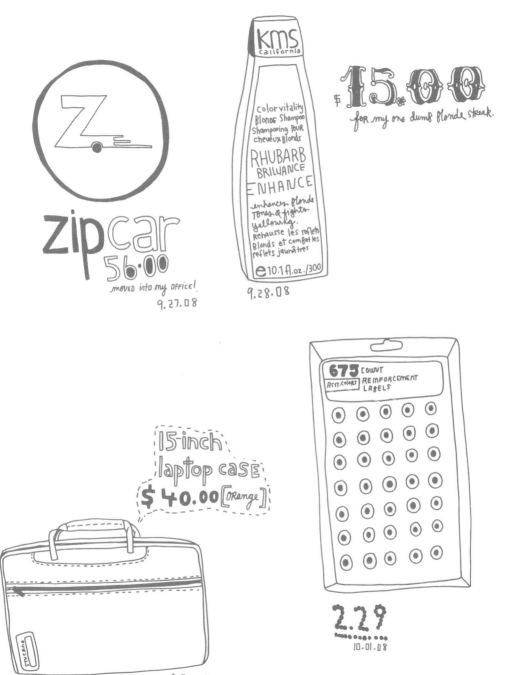

zip car
56.00
moved into my office!
9.27.08

KMS california
Color vitality
Blonde Shampoo
Shampooing pour
cheveux blonds
RHUBARB
BRILLIANCE
ENHANCE
enhances blonde
tones & fights
yellowing.
Rehausse les reflets
blonds et combat les
reflets jaunâtres
e 10.1 fl. oz. /300
9.28.08

$15.00
for my one dumb blonde streak.

15-inch
laptop case
$40.00 [Orange]
9.30.08

675 COUNT
ASST.COLORS
REINFORCEMENT
LABELS
2.29
10.01.08

177

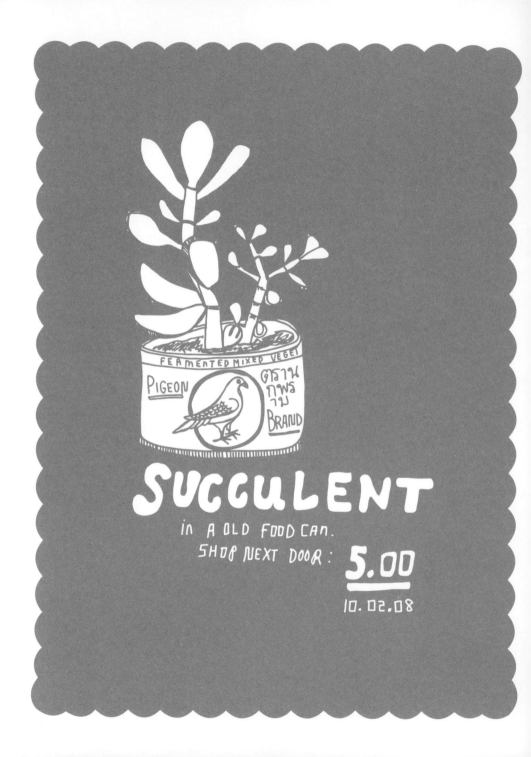

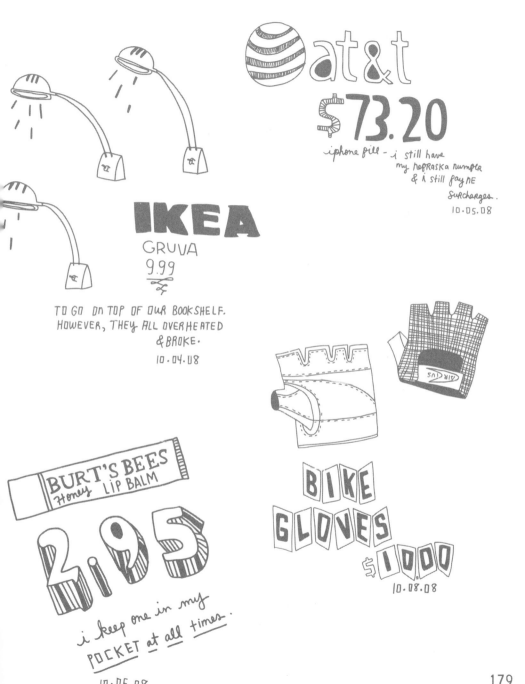

at&t

$73.20

iphone bill - i still have
my nebraska number
& i still pay NE
surcharges.
10.05.08

**IKEA**
GRUVA
9.99

TO GO ON TOP OF OUR BOOKSHELF.
HOWEVER, THEY ALL OVERHEATED
& BROKE.
10.04.08

BURT'S BEES
Honey LIP BALM

2.95

i keep one in my
POCKET at all times.
10.06.08

BIKE GLOVES
$10.00
10.08.08

179

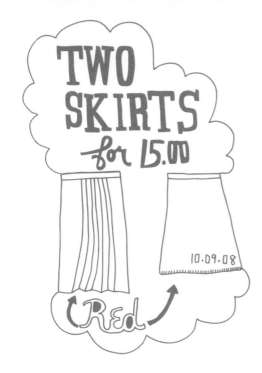

TWO SKIRTS for 15.00

10.09.08

Red

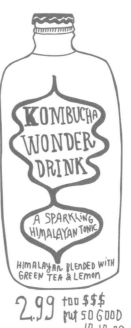

KOMBUCHA WONDER DRINK

A SPARKLING HIMALAYAN TONIC

HIMALAYAN BLENDED WITH GREEN TEA & LEMON

2.99 too $$$ but SO GOOD
10.10.08

Portland General Electric $33.85

WAy cheaper than Starkville, MS electric.

10.11.08

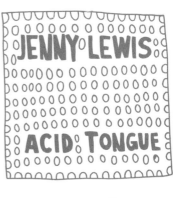

JENNY LEWIS

ACID TONGUE

FROM itunes

10.12.08

# Chicken Pot Pie 4.95

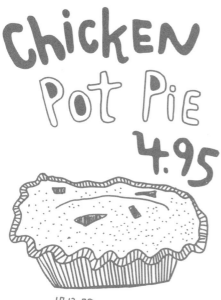

10.13.08
FALL FOOD

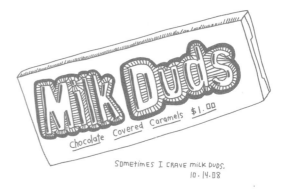

Mik Duds
chocolate covered caramels $1.00

SOMETIMES I CRAVE MILK DUDS.
10.14.08

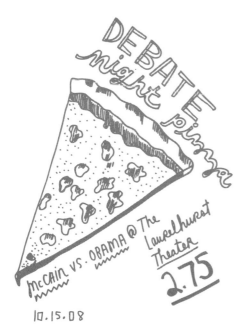

DEBATE night pizza

McCAIN VS. OBAMA @ The Laurelhurst Theater
2.75

10.15.08

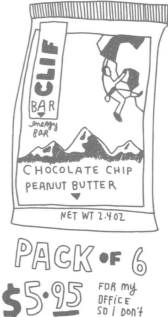

CLIF BAR
energy BAR
CHOCOLATE CHIP PEANUT BUTTER
NET WT 2.4 OZ

PACK OF 6
$5.95   FOR MY OFFICE SO I DON'T PASS OUT.
10.16.08

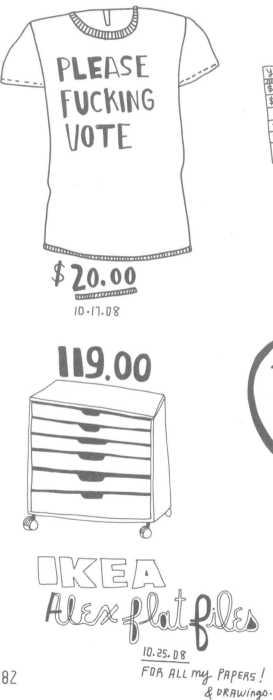

PLEASE FUCKING VOTE

$20.00
10·17·08

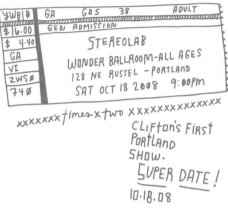

| YWR10 | GA | GAS | 38 | ADULT |
| $16.00 | GEN ADMISSION |
| $4.40 | STEREOLAB |
| GA | WONDER BALLROOM-ALL AGES |
| VI | 128 NE RUSSEL - PORTLAND |
| ZWS0 | SAT OCT 18 2008    9:00PM |
| 740 |

xxxxxxx times x two xxxxxxxxxxxxx

CLifton's First
Portland
Show.
SUPER DATE!
10·18·08

119.00

IKEA
Alex flat files
10·25·08
FOR ALL my PAPERS!
& DRAWINGS.

Pine State
BISCUITS

2 COFFEES
2 CHEESE, EGG & SAUSAGE Biscuits
$17.00 DOLLARS
10·26·08

182

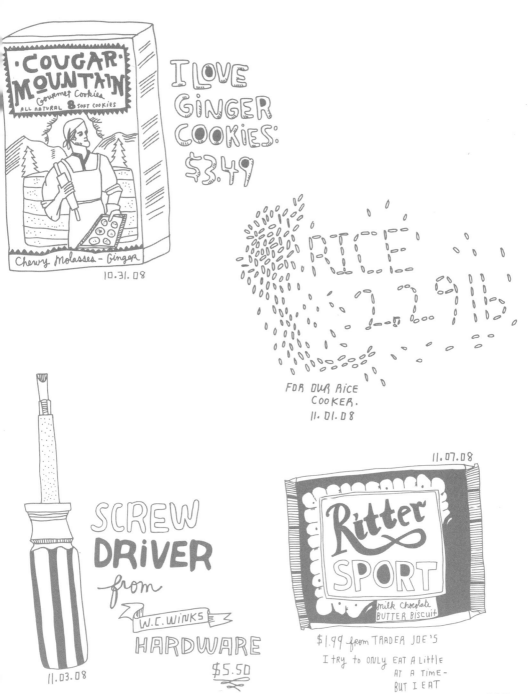

·COUGAR·
MOUNTAIN
Gourmet Cookies
ALL NATURAL 8 SOFT COOKIES

Chewy Molasses - Ginger

10.31.08

I LOVE
GINGER
COOKIES:
$3.49

RICE
$2.29/lb.

FOR OUR RICE
COOKER.
11.01.08

SCREW
DRIVER
from
W.C. WINKS
HARDWARE
$5.50

11.03.08

11.07.08

Ritter
SPORT
milk chocolate
BUTTER BISCUIT

$1.99 from TRADER JOE'S
I try to ONLY EAT A Little
AT A TIME—
BUT I EAT
it ALL.

183

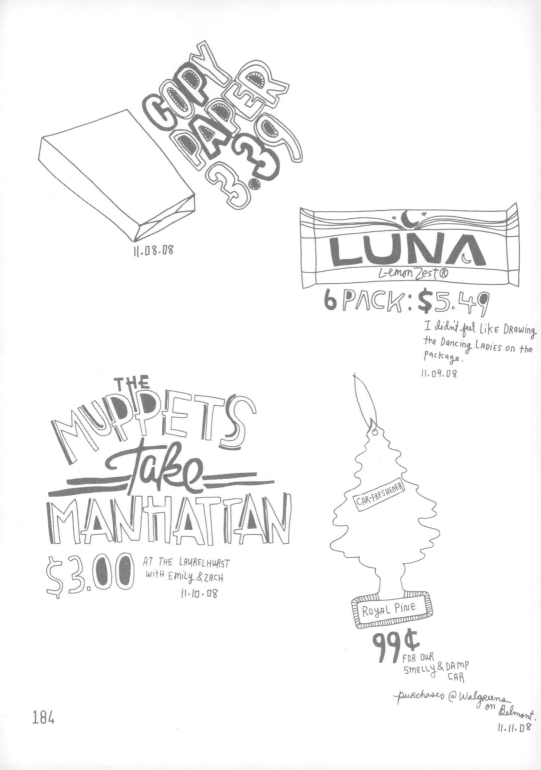

COPY PAPER 3.39

11.08.08

LUNA
Lemon Zest®

6 PACK: $5.49

I didn't feel like Drawing
the Dancing Ladies on the
package.
11.09.08

THE MUPPETS take MANHATTAN

$3.00  AT THE LAURELHURST
WITH EMILY & ZACH
11.10.08

CAR-FRESHENER

ROYAL PINE

99¢
FOR OUR
SMELLY & DAMP
CAR

purchased @ Walgreens
on Belmont.
11.11.08

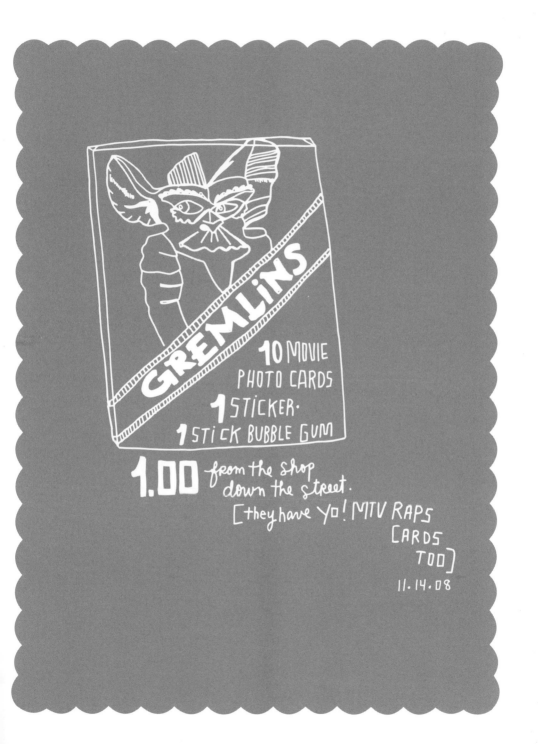

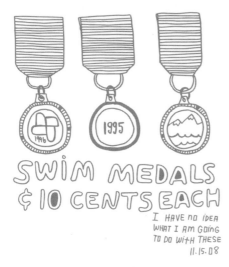

SWIM MEDALS
¢ 10 CENTS EACH

I HAVE NO IDEA
WHAT I AM GOING
TO DO WITH THESE
11.15.08

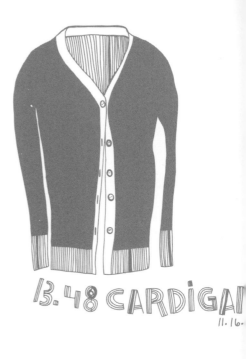

13.48 CARDIGAN
11.16.

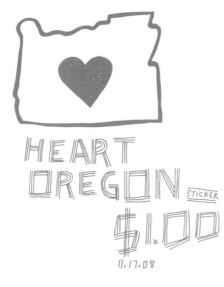

HEART
OREGON STICKER
$1.00
11.17.08

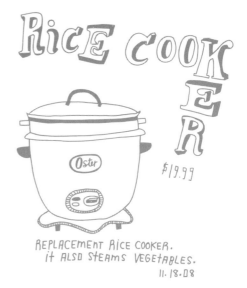

RICE COOKER
$19.99

REPLACEMENT RICE COOKER.
IT ALSO STEAMS VEGETABLES.
11.18.08

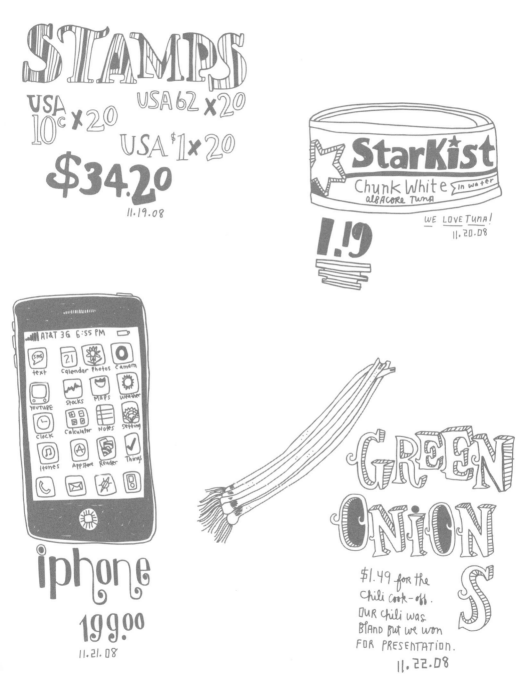

STAMPS
USA 10¢ × 20
USA 62 × 20
USA $1 × 20
$34.20
11.19.08

StarKist
Chunk White in water
albacore tuna
1.19
WE LOVE TUNA!
11.20.08

iphone
199.00
11.21.08

GREEN ONIONS
$1.49 for the Chili Cook-off.
OUR chili was BlAND but we won FOR PRESENTATION.
11.22.08

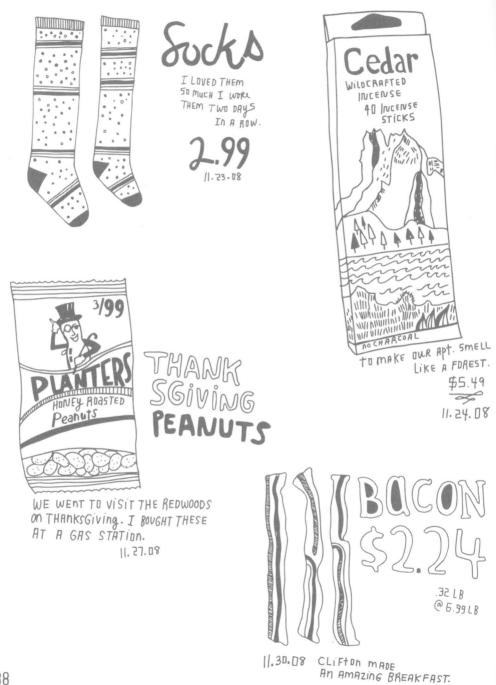

# Socks

I LOVED THEM SO MUCH I WORE THEM TWO DAYS IN A ROW.

**2.99**

11.23.08

# Cedar

WILDCRAFTED INCENSE
40 INCENSE STICKS

NO CHARCOAL

TO MAKE OUR APT. SMELL LIKE A FOREST.

$5.49

11.24.08

# THANKSGIVING PEANUTS

3/99

PLANTERS
HONEY ROASTED Peanuts

WE WENT TO VISIT THE REDWOODS ON THANKSGIVING. I BOUGHT THESE AT A GAS STATION.

11.27.08

# BACON $2.24

.32 LB @ 6.99 LB

11.30.08 CLIFTON MADE AN AMAZING BREAKFAST.

**5.00**

DECAF LATTE
TALL
FOR LIS

MOCHA TALL
FOR ME
12.01.08

JORDACHE®

On Sale
20% off 20% off
Reg 79.00 each
$31.00/unit discount
Reg 79.00 each
$39.00/unit discount

— Morgan straight leg
— Falcon skinny
12.03.08

MEASURING CUPS: 2.99
12.07.08

---

Portland State
UNIVERSITY
PARKING VIOLATION

Citation #CY34552
ISSUE DATE: 12/08/08
ISSUE TIME: 11:47  OFFICER: 021
LOCATION: ART BUILDING
CITATION CODE: 45

VIOLATION: EXPIRED
FINE AMOUNT: $25.00

MAKE: TOYOTA
COLOR: BLACK

PSU TRANSPORTATION &
PARKING
PO BOX 751 PORTLAND, OR
97207

12.08.08

189

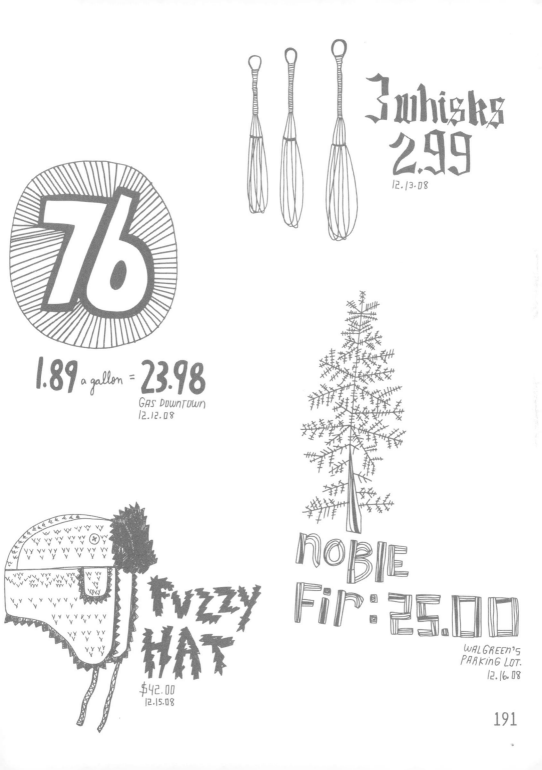

3 whisks
2.99
12.13.08

76

1.89 a gallon = 23.98
GAS DOWNTOWN
12.12.08

NOBLE
FIR: 25.00
WALGREEN'S
PARKING LOT.
12.16.08

FUZZY
HAT
$42.00
12.15.08

191

# EARL GREY LATTE

## 3.75

12.17.08

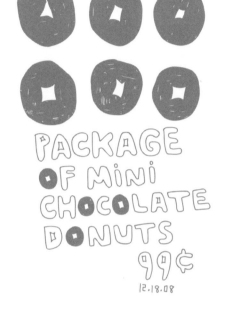

# PACKAGE OF MINI CHOCOLATE DONUTS

## 99¢

12.18.08

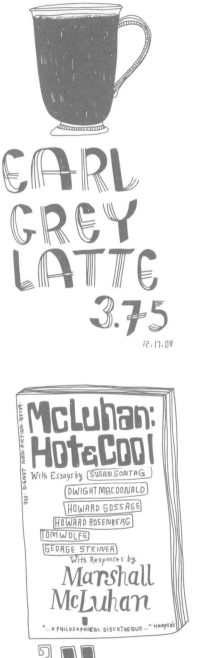

# McLuhan: Hot & Cool

HOWARD · SIGNET NON-FICTION · Q3798 · 95¢

With Essays by SUSAN SONTAG
DWIGHT MACDONALD
HOWARD GOSSAGE
HOWARD ROSENBERG
TOM WOLFE
GEORGE STEINER
With Responses by
*Marshall McLuhan*

"...a philosophical discotheque..." HARPER'S

## 2.00

12.20.08

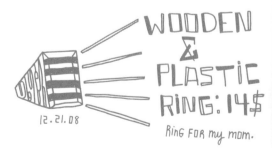

# WOODEN & PLASTIC RING: 14$

12.21.08

*Ring for my mom.*

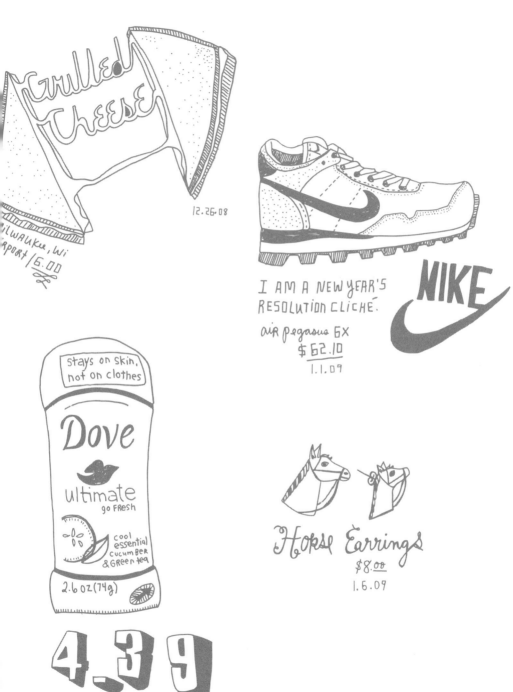

Grilled Cheese
12.26.08
Milwaukee, Wi
airport / 6.00

I AM A NEW YEAR'S
RESOLUTION CLICHÉ.
air pegasus 6X
$62.10
1.1.09

NIKE

stays on skin,
not on clothes

Dove
ultimate
go FRESH

cool
essential
cucumber
& Green tea

2.6 oz (74g)

Horse Earrings
$8.00
1.6.09

4.39
1.2.09

193

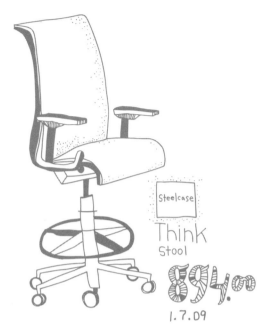

Steelcase
Think
Stool
894.00
1.7.09

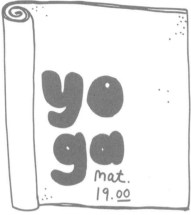

yo
ga
mat.
19.00
1.10.09

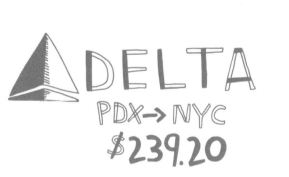

DELTA
PDX→NYC
$239.20

FOR HANDMADE NATION!
1.14.09

32 LBS
Tide
FRONT LOADERS
ORIGINAL SCENT

normally i do not buy TIDE—
This was onsale : $7.99

1.18.09

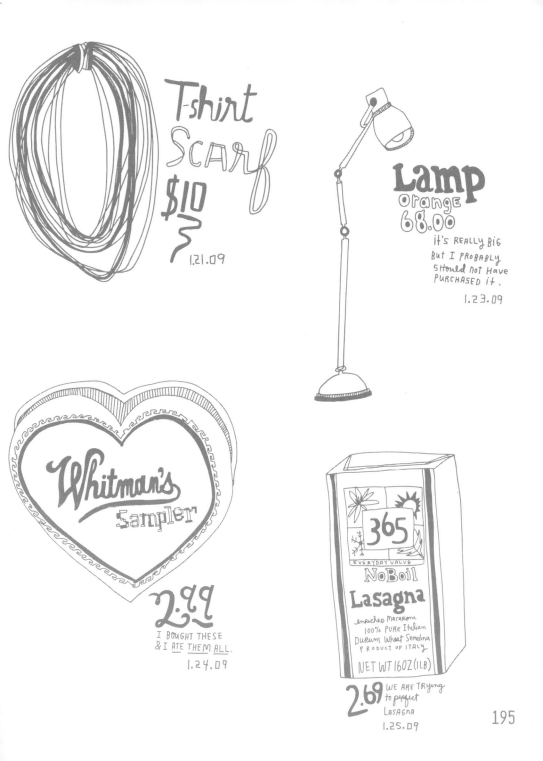

T-shirt
SCARF
$10
1.21.09

Lamp
orange
68.00
it's really big
but I probably
should not have
purchased it.
1.23.09

Whitman's
Sampler
2.99
I bought these
& I ate them all.
1.24.09

365
EVERYDAY VALUE
NoBoil
Lasagna
enriched macaroni
100% PURE Italian
Durum Wheat Semolina
PRODUCT OF ITALY
NET WT 16OZ (1LB)
2.69 we are trying
to perfect
Lasagna
1.25.09

195

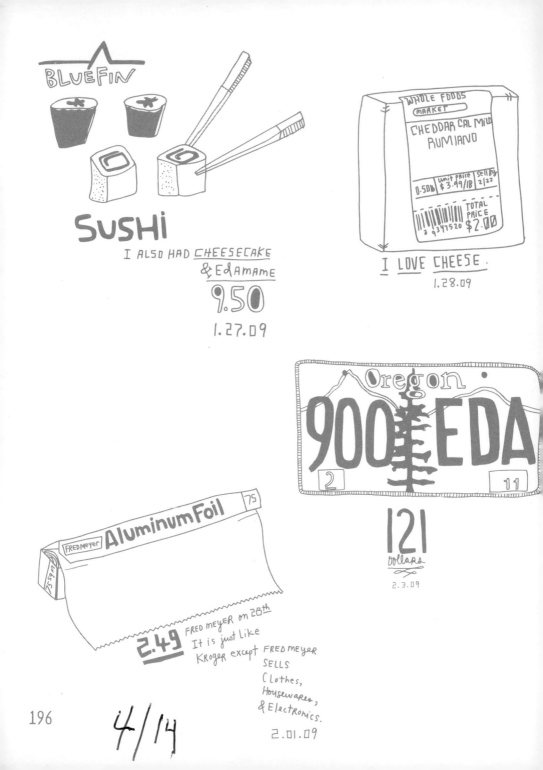

BLUEFIN

## Sushi

I ALSO HAD _CHEESECAKE_
_& Edamame_

**9.50**

1.27.09

WHOLE FOODS
MARKET
CHEDDAR CAL Mild
RUMIANO

| 0.50lb | unit price $3.99/lB | sell By 2/22 |

TOTAL PRICE
**$2.00**

I LOVE CHEESE.
1.28.09

Oregon
**900 EDA**
2                    11

**121**
dollars
2.3.09

75
FRED meyer **Aluminum Foil**

**2.49**

FRED meyer on 28th
It is just like
KROGER except FRED meyer
SELLS
Clothes,
Housewares,
& Electronics.
2.01.09

196        **4/14**

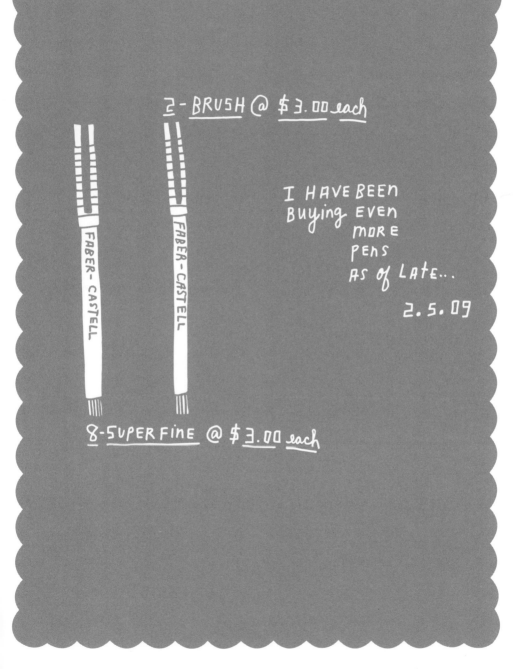